CHESTER
PUBS

PAUL HURLEY & LEN MORGAN

AMBERLEY

We have benefited from the assistance given by historian Steve Howe who allowed us to dip into his excellent series of websites at http://www.chesterwalls.info/. If your interest is Chester history then this website should be in your list of favourites. We also thank John Pritchard for his photo of the Olde Cottage on behalf of the landlord Trevor. Also thanks go out to our editor Vanessa Le for her patience, and finally our wives Rose and Joan for their patience during the writing and compilation of the book.

First published 2015

Amberley Publishing
The Hill, Stroud
Gloucestershire, GL5 4EP

www.amberley-books.com

Copyright © Paul Hurley & Len Morgan, 2015
Maps contain Ornance Survey data.
Crown Copyright and database right, 2015

The right of Paul Hurley & Len Morgan to be
identified as the Authors of this work has been
asserted in accordance with the Copyrights,
Designs and Patents Act 1988.

ISBN 978 1 4456 4736 4 (print)
ISBN 978 1 4456 4737 1 (ebook)

British Library Cataloguing in Publication Data.
A catalogue record for this book is available from
the British Library.

Typesetting by Amberley Publishing.
Printed in the UK.

Contents

About the Authors

Paul Hurley is a freelance writer, author and is a member of the Society of Authors. He has written a novel and has newspaper and magazine credits. He also has a Facebook Group 'Mid Cheshire Through Time' that all are welcome to join. Paul lives in Winsford, Cheshire with his wife Rose. He has two sons and two daughters. www.paul-hurley.co.uk. Books by Paul Hurley:

Middlewich (with the late Brian Curzon)
Northwich Through Time
Winsford Through Time
Villages of Mid Cheshire Through Time
Frodsham and Helsby Through Time
Nantwich Through Time
Chester Through Time (with Len Morgan)
Middlewich & Holmes Chapel Through Time
Sandbach, Wheelock & District Through Time
Knutsford Through Time
Macclesfield Through Time
Cheshire Through Time
Northwich, Winsford & Middlewich Through Time
Chester in the 1950s
Chester in the 1960s
Villages of Mid Cheshire Through Time revisited
Waffen SS Britain (fiction)

Len Morgan is a popular local historian who was born within the city walls so is a true Cestrian. He writes a weekly column in the *Chester Leader* looking at different aspects of Chester history, he contributes to other publications and also lectures on the subject. In 2005 he co-compiled a book titled *Twentieth Century Handbridge* with the late Noel St John Williams. Len still lives in Chester and has been married to Joan for 60 years, they have three children and eight grandchildren. Len is still very active as a local historian with frequent talks and guided tours in Chester. Books by Len Morgan:

20th Century Handbridge
Chester Through Time (with Paul Hurley)

Introduction

What a pleasure it is to compile another book on the beautiful city of Chester, once again with my good friend Len Morgan, a real Cestrian and superb local historian and raconteur. This time we take a look at the pubs of this great city. At one time there were as many as 365 public houses for the people of Chester and the city's many visitors to choose from. This figure has dropped dramatically over the years lately for several real or supposed reasons. The price of drinks, the smoking ban or simply more avenues of entertainment to be investigated, whatever the cause we have seen the conversion to other uses and the demolition of many of Chester's pubs. In this book we will look at the pubs that are still here in the city and some of those ancient watering holes that have been lost forever. The many pubs that went in the 1960s to make way for the new Inner Ring Road included the ancient Yacht Inn that was situated in Nicholas Street. Here the author and satirist Jonathan Swift, when snubbed by the churchmen of the cathedral, scratched on the window 'Rotten without and mould'ring within, this place and its clergy are all near akin.' The Castle Inn is now demolished and a 'modern' building built in its place.

The unique King's Arms Kitchen with its fake council chamber and 'mayor's' chair where anyone with the temerity to sit upon it had to buy drinks all round. The pub has been incorporated into the building next door but the interior has been re-constructed in the Grosvenor museum. But these are pubs that are with us no longer and we will give them a mention but there are still plenty of establishments still existing such as The Dublin Packet that once boasted the famous football icon Dixie Dean as its landlord. Pubs that have existed through the ages like the Old Boot Inn that first opened its doors to the people of Chester in 1643. The Bear and Billet that was built in 1664 and was the birthplace of John Lennon's maternal grandmother, Annie Jane Milward. The even older Falcon that started life as a house in around 1200. But of course we will have to take a quick look at the modern pub eateries that have become popular, not perhaps in the way ordinary pubs once did but they serve a purpose for a modern generation with taste buds far more experimental than their forefathers. There are quite a few old pubs in Chester city that perform the same service as they have for generations, The Albion and the Union Vaults to name just two. These are examples of what the book has to offer when we later look at them in more detail, including up-to-date photographs.

As I mentioned earlier, Chester once boasted around 365 public houses; it's easy to work out that you would have a different one for every day of the year. The traditional pub had a bar, a lounge a smoke room, a tap room and snug for the ladies, even in some pubs, a dedicated Ladies' room. There was also an off-licence for the purchase of drink to be enjoyed elsewhere, possibly using your own jug for the beer and also possibly sending your child out with said jug for said beer! Today they fall mainly

into four categories: those that have survived intact although most have been altered with renovated interiors; those that have had a change of name that many purists find extremely annoying, especially in an ancient city like Chester although the monolithic new brewing companies seem to prefer it; those where the building still stands but has had a change of use unconnected with the sale of alcohol, and the many pubs that have been demolished to make way for other developments, roads, housing, car parks and shops.

This has not been a one-way street though; companies such as Wetherspoons and other private companies have converted attractive and not so attractive buildings into public houses. A complete history of Chester and its pubs would fill many volumes so accordingly we have had to be selective with our choices, giving priority to pubs still with us and those that have enjoyed longevity and are still bucking the current trend to close down non-profit-making pubs and those in the way of progress. In this book we have confined our area to the city centre and its very close confines using photographs of the most photogenic of buildings. This is not too difficult as so many beautiful pubs exist in Chester thanks to the changes that took place a hundred or so years ago. True purists criticise the mock Tudor as being unlike the buildings that they replaced, or that the buildings that they replaced were knocked down in the first place, but if you peruse photographs of those few demolished buildings for which photos exist, you may see what I mean. I personally think that the mock Tudor is very attractive and makes Chester one of the most visited towns in the country.

At the end of the book you will find an appendix showing nearly all of the Chester public houses still there, put to other use or simply demolished from 1900 to the present day.

Chapter One

Chester Pubs That Still Trade Within the Walls

Chester is the best known walled city in Great Britain with the walls just about intact so I have used the walls to separate the area that we are looking at. This first chapter comprises the city centre with the famous Chester Cross in the middle; it no longer resembles a cross but the area has been known as The Cross for centuries. Let us just have a look at this antiquity. The original cross dated from the fourteenth century and this one was replaced by a new one in 1476. At the time it consisted of an octagonal pillar surmounted by a carved head and a crucifix on the top. In 1603 the cross was gilded and then along came the English Civil War in 1646 when the purist Parliamentarians did what they did elsewhere, including Sandbach, and they smashed it down. The head of the cross was saved and in the nineteenth century other bits of it were rediscovered: some parts were under St Peter's church porch and they were used in the restoration of the cross and in 1949 it was erected near the Newgate. In 1975 it was moved to its present and original position.

Chester is also famous for its 'Rows', that is, shops and establishments on two floors. As a result, the first pubs that we look at are actually on the Upper Row with shops and other businesses below. So starting with the pub that is actually at The Cross, let's take a look at The Victoria.

The Victoria

The land that the pub stands on was quite important even before it was built as it housed the headquarters of the Roman legion that was based in Chester. It first became a pub in 1269 and it remained as such, on and off, to the present day but not with the same name; one of its names was The Fox & Goose and it received its current name around 1897 at the time of Queen Victoria's Golden Jubilee. It was also believed that at one time the building was owned by William Bulkeley, the Archdeacon of Dublin. The shop below The Victoria was sometimes sold with the pub and other times independently. Being close to St Peter's church, the pub provided accommodation for pilgrims through the centuries, in fact the cellar is over St Peter's crypt and the courtyard that forms a pleasant outside patio is part of the, flagged-over, graveyard

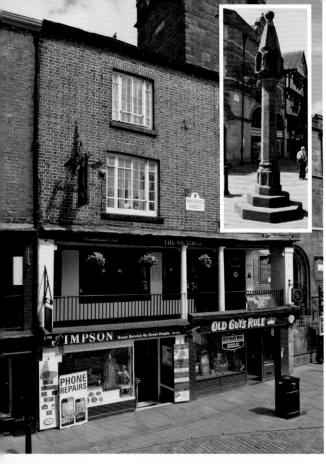

Left: The Victoria.

Below: The interior of The Victoria.

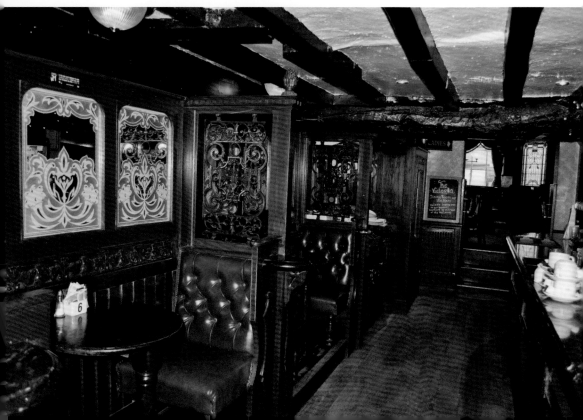

of St Peter's church next door. The pub is still open and going strong and still with an interior filled with the ambience of old including one exposed beam that has been there for 762 years. The steps to the Watergate Row, where The Victoria is the first building, are at the side of The Cross (as shown in inset opposite).

Amber Lounge

Next door to The Victoria on the Rows is another ancient pub that I believe was built at the same time as the adjoining Victoria: The Amber Lounge. A modern name perhaps, but this has not always been the case, as within the building is an Elizabethan staircase and a fireplace that is dated 1509. It has been a pub since 1634 when it was called The Moon; in 1822 it became The Albion Tavern and in 1873 it was split into two when the ground floor and the upper floor had their own names: The Moon and The Albion. This only lasted for four years at which time it was purchased by the Northgate Brewery and both pubs reunited under the name The Moon or in ancient speak The Mark of The Moon. In 1892 it spent another year as The Albion and then the name that carried it forward into the latter part of the 1900s, Ye Deva. The pub has now been given a modern name and modernised within.

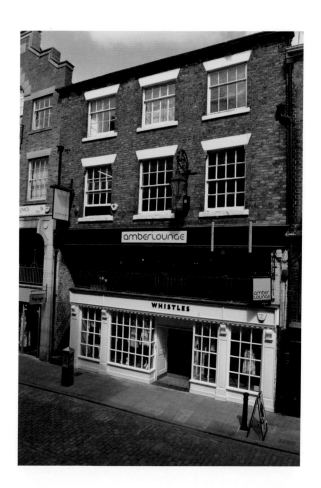

Amber Lounge.

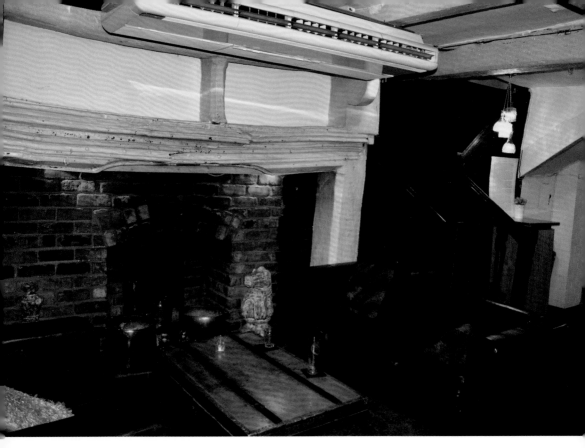

The interior of The Amber Lounge.

Watergates Bar

Walking along Watergate Street from The Cross we come to a more modern pub with an ancient aspect, Watergates Bar, or The Watergates.

This pleasant gastro pub is situated in one of Chester's ancient crypts built below the Rows above. The ancient brickwork in what was a medieval undercroft has been left exposed, including the curved ceiling and church-like architecture that dates from around 1180. An atmospheric and interesting bar. What better place to take a look at this most famous of streets in Chester, Watergate Street. The street extends from The Cross to the old Watergate where in days of old ships would unload cargo from the navigable River Dee. Now when you pass through the gate you find the equally famous Chester Racecourse known as the Roodee. We will look at this further later. Watergate follows the line of the Roman street *Via Principalis* until it reaches the Inner Ring Road which was then the limit of the Roman fortress. Later developments around the 1600s saw the street acquire some beautiful buildings including Bishop Lloyd's Palace, and other interesting buildings including God's Providence House, where during one of Chester's raging plagues, the residents were all saved from the sickness as the rest of Chester saw its population decimated. It was thought that God had saved them and from then on the building was known as God's Providence House.

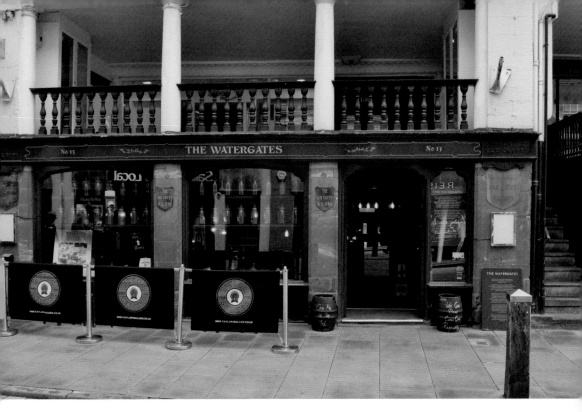

Above: The Watergates.

Below: The interior of The Watergates.

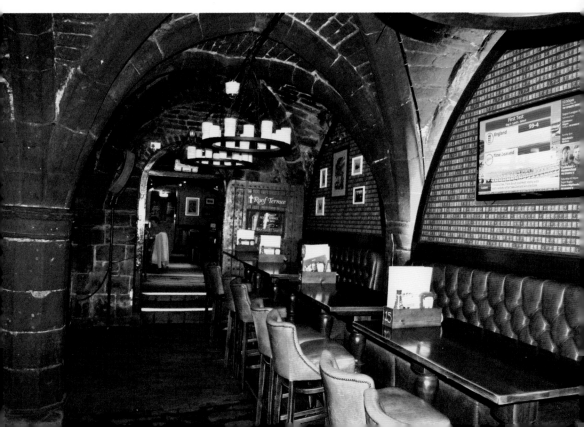

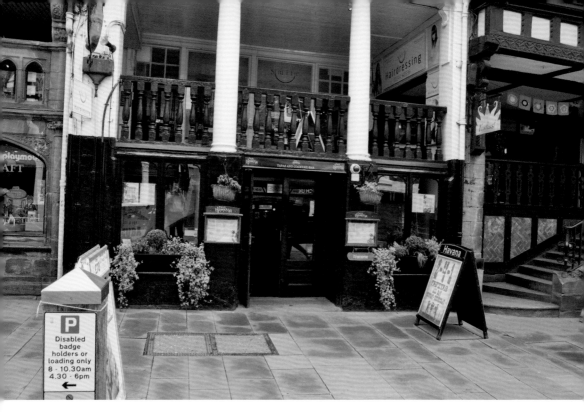

Above: Fiesta Havana Bar and Tapas, Watergate Street.

Below: The interior of Fiesta Havana.

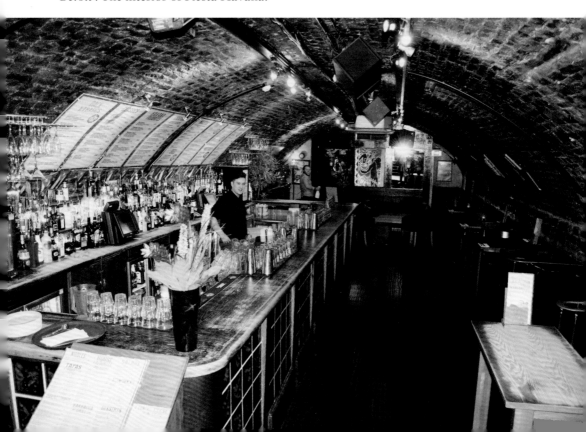

Fiesta Havana Bar and Tapas

Fiesta Havana is a new Latin-style bar in Watergate Street. Like The Watergates it is situated in an ancient undercroft with the rows above it. In other towns this attractive arched brick ceiling is replicated to increase the ambience. In Chester there is no need for that: all businesses have to do is take advantage of the ancient and original undercroft cellars. In this case we have a new arrival in Chester in the form of a little piece of Cuba with its smooth Latin-style and infectious rhythms of the Caribbean. The Mojito is the bar speciality and cocktail-mixing lessons are a regular feature. Rums and tequila are always available as are fajitas, tempting tapas and music. Here you will find the best mix of Latin, infused with British dance where you can eat, drink and party all in one attractive and ambience-filled bar in an undercroft that was built hundreds of years ago and can be viewed from your seat.

Old Custom House Inn

This building, now the Old Custom House Inn, was built originally as two adjoining houses, Nos 69 and 71 as a town house in 1637 for Thomas and Anne Weaver. The lane at the side is called Weaver Street after them. You can still see their initials carved on the front and it later became a pub named The Star Inn. It originally had a row passing through it but this was enclosed in 1711; the inn formally had a cottage attached to its rear. It was renamed in the eighteenth century to refer to the real custom house building across the street when goods brought ashore, in the days when Chester was a thriving port, would be brought up the street from the Watergate to the custom house. Here dues would be paid prior to onward transmission for sale in the city centre and elsewhere. In 1828 the landlord was Joseph Walker. It's interesting to note that in the 1950s when Wales was 'dry' on a Sunday, this was the only pub in Chester selling border ales from Wrexham. On Sunday night it was packed! Still open today and it's business as usual.

Old Custom House Inn, 1905.

Above: Old Custom House Inn, 2015.

Below: The interior of the Old Custom House Inn.

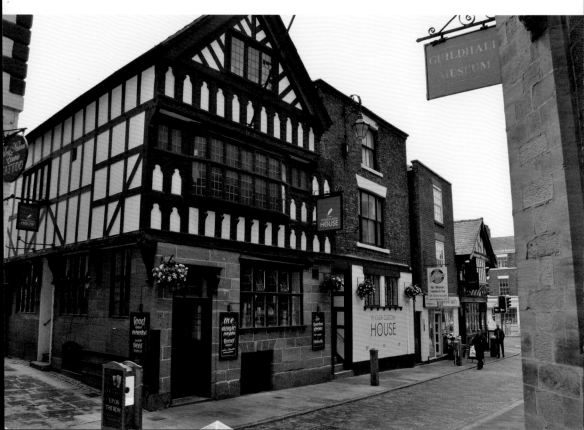

Bar Lounge

Not quite as old as The Old Custom House, The Axe was a small pub built in the traditional mock Tudor and, with the demolition that was carried out in the 1960s to build the Inner Ring Road, it now finds itself not two buildings away from the ancient Yacht Inn, but as the final building in upper Watergate Street at the junction with St Martin's Way, the Inner Ring Road. It is possible to trace it back to the beginning of the 1800s. In 1860 the pub now sitting just down from the Old Custom House Inn was called The Axe Tavern and William Edwards was the landlord. He was not the first though, in 1828 the pub was known as The Old Axe Tavern and then in 1840 it was simply The Axe and it retained this name until around 1914 when its address returned to The Axe Tavern. Then along came the trend for daft pub names and for a while it was The Falchion & Firkin. Now after another transformation it has become The Bar Lounge, a very successful pub that has brought together the inside and the outside to give a large comfortable all-weather seating area, of which the small Axe Tavern makes up the interior bar area as can be seen in the interior photograph. Al fresco dining and drinking is on offer here with an all-weather outside area that does more than just provide a few wooden benches.

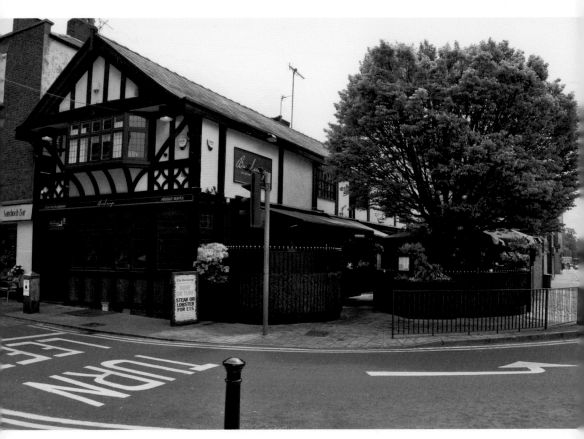

Bar Lounge/Axe Tavern.

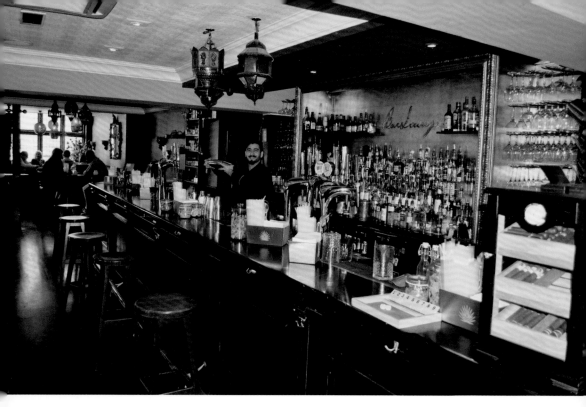

The interior of Bar Lounge.

The Architect

Turning now into Nicholas Street we pass the site of the ancient Yacht Inn and cross the road onto what was once called Pillbox Promenade or Row. A row of attractive large Georgian terraced houses that once was the London Harley Street, or in Liverpool, the Rodney Street of Chester with many doctors' premises, hence the name. But carrying on towards the Abode Hotel and council offices we arrive at a beautiful old mansion house set back in its own grounds. The impressive house was built for, and designed by, the renowned architect Thomas Harrison (1782–1828) who was responsible, amongst other things, for rebuilding Chester Castle opposite the house. He incorporated the Assize Court, prison, armoury and gateway. He later designed Chester's superb Grosvenor Bridge that when built was the longest single-span arch bridge in the world. Harrison unfortunately died two years into the construction of this, his greatest work, and the bridge was completed by his pupil William Cole and opened by the future Queen Victoria.

But back to the house: it was built as The Rectory and later St Martin's Villa on the site of convent gardens. During medieval times and prior to the dissolution of the monasteries, this whole area was occupied by religious institutions, hence the road names in the area: Whitefriars, Greyfriars, Blackfriars, Nuns Road etc. The Cheshire police headquarters once occupied the ground upon which The Abode Hotel and council offices now stand and as the building progressively became too small one of the satellite buildings that they moved into was St Martin's Lodge as it became known.

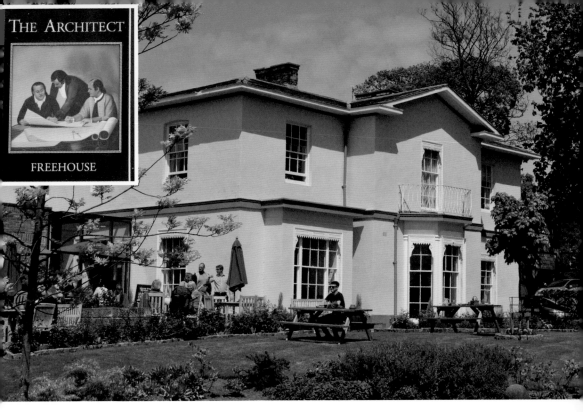

Above: The Architect Inn.

Below: The interior of The Architect Inn.

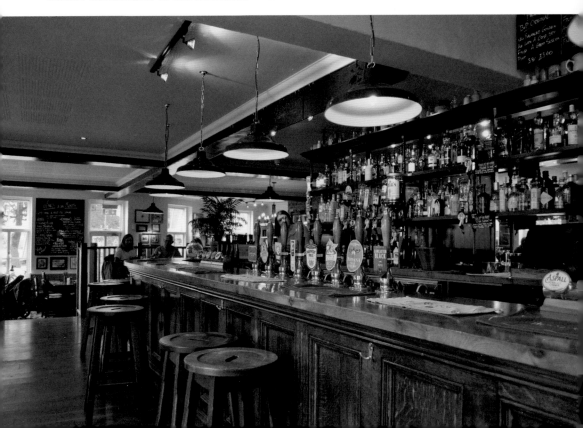

When the force relocated to Winsford it remained empty for a while until the Brunning & Price pub company purchased it, completely renovated it back to its former glory and opened it as a most impressive public house that is a favourite of its food-loving patrons. Outside is a large grassed area with seats on which to sit to enjoy the views towards the Roodee. It is worth noting here that my co-compiler, when working for BT was in the police headquarters next door when he saw below, something in the long grass at St Martin's Lodge, then also an annex of the police headquarters. With permission he investigated and found the stone font of St Bridget's church. This church was on the corner of Whitefriars and was demolished in 1892 to make way for the road widening from the Grosvenor Bridge. It was in this font that Thomas Harrison's daughter had been christened. When the man himself died he was buried at St Bridget's in a graveyard that would now have been on the large roundabout opposite, but his body was removed from there and reinterred at Blacon cemetery. The font is now a feature in the gardens of The Architect.

But back now to The Cross and a look at the pubs still open in Market Square and Northgate Street.

The Commercial Hotel

Situated in St Peter's churchyard behind the church and The City Club is The Commercial Hotel, a Grade II-listed building and it has been there since around 1817. It was not the first public house on the site as it is believed that a pub called The Rising Sun had occupied the site since around 1630. The Commercial became a long-standing and popular pub, with Charles Sandford taking over in 1828 and remaining as mine host for many years. It was known then as The Commercial Tavern. By 1860 Mary Shepherd had taken over, and its name had changed to The Commercial Inn.

It occasionally gets mixed up with Chester's Commercial Newsrooms. This building is situated at 1 Northgate Street nearby and had been designed by the already mentioned, famous architect Thomas Harrison and built in 1807. That building became known as The Commercial Coffee Room and later The Commercial Newsroom. In 1815 the contents of the City library found their temporary home here but it was later transferred to the Mechanics Institute to await a more permanent home in the new city library in 1877. The Newsroom had its own committee and at the time its automatic members included the city mayor, the local MPs and senior military officers. Since the middle of the nineteenth century it has been known as The Chester City Club, one of the oldest Gentlemen's clubs in the country, only beaten by London.

But back to the Commercial bar and hotel that is flourishing in the centre of the city and it has the same friendly atmosphere as it did many years ago. This has not always been the case. In 2005 it fell on hard times when a national tavern chain tried to modernise it and there was a fire, leaving it like other pubs, closed and boarded up, but like the nearby Coach & Horses it was brought back to life and unlike the latter it retained its name. Since re-opening, it has already won the Best Newcomer and Best Bar awards at the Chester Food & Drink Festival and was also voted the third-best designer hotel in Cheshire by Trivago. It now welcomes customers with a free pizza, the only condition is that they purchase a few drinks. There is regular live

Above: The Commercial Hotel.

Below: The interior of The Commercial Hotel.

music, sometimes in the courtyard under the stars and resident DJs are in attendance to provide their own form of entertainment. And remember, there is free pizza for those who purchase two full-price drinks from Monday to Thursday from 5 p.m. to 8 p.m. The Commercial is surely one of Chester's hidden gems and can be reached by walking up the passageway at the back of St Peter's church.

The Dublin Packet

Situated at the side of the Market Square, this cosy pub has now been half hidden by the questionable rebuilding that took place some time ago. The pub is not shown in the 1782 directory but is in the 1876 one when John Smith was the landlord and even earlier in 1829 when William Rogers was at the helm. It is believed that the name comes from the time when a packet boat would leave Chester docks for Dublin regularly. There was a more famous landlord later in the pub's life though. A gentleman by the name of William Ralph 'Dixie' Dean who during a glowing football career played for a number of teams, notably Everton when he was known as England's greatest goal scorer. His international debut came playing for England against Wales at the Racecourse ground in Wrexham in 1927 just after he turned twenty years old. The result was a 3-3 draw with Dixie scoring twice. During his international career he won sixteen England caps and scored eighteen goals for England.

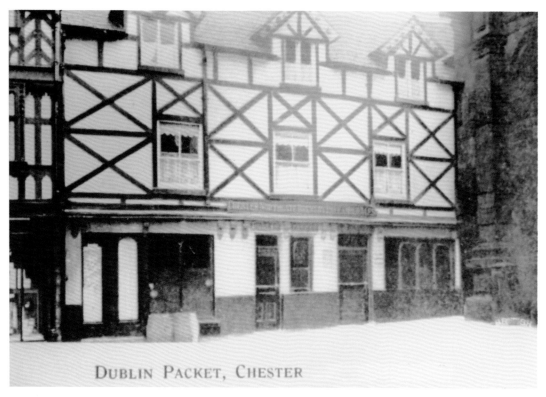

The Dublin Packet, 1930s.

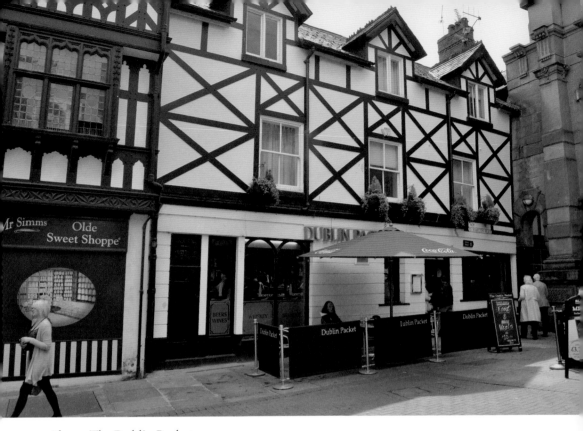

Above: The Dublin Packet, 2015.

Below: The Interior of the Dublin Packet.

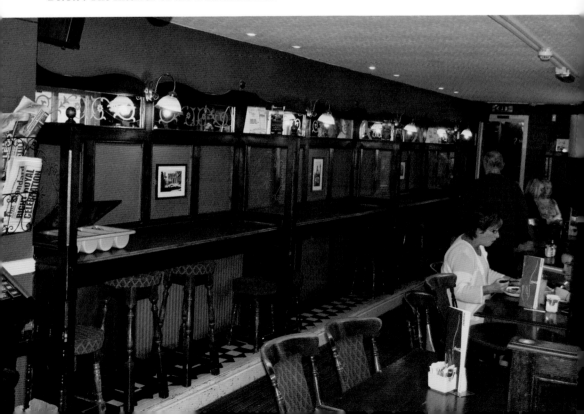

In these days when top football players earn enormous wages and retire to a life of luxury, Dixie Dean followed up an exceptionally successful career in football, as a shopkeeper of sports goods in Birkenhead but only for a short while. Then along came the war and Dixie was called up and had a good army career playing and managing service football as well as being a corporal mechanic: imagine Beckham finishing his career as a lowly paid mechanic instructor! Shortly after the war, this football legend took over the Dublin Packet and remained there for around sixteen years. Even then he continued to play, this time for the Northgate Brewery team. This was the heyday of the Dublin Packet, a very happy pub that was constantly visited by the famous and not so famous paying homage to the great man.

The Coach House

We now go into the Market Square and find an old pub that for a while was closed. If this isn't an example of a decline in our pub stock I don't know what is. This old and very attractive pub in the centre of, arguably, the number one tourist city in Britain was closed and boarded up! Fortunately this did not last and it is now once again open and successful albeit that it is now called The Coach House. Situated almost opposite Chester Cathedral and next to the Town Hall and shown in the Chester Directory of 1781 as a pub called the Coach & Horses in Northgate Street with the landlord Mr Davies. In 1872 the building had the front remodelled in mock Tudor by pupils of James Harrison but the fabric of the building dates from the early seventeenth century. It stands near the site of the White Lion, a noted coaching pub that we will look at later

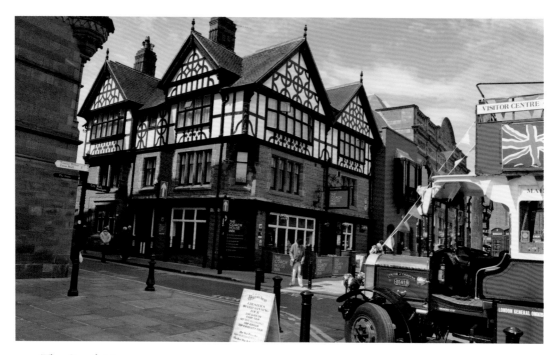

The Coach House.

The interior of the Coach House.

but the Coach & Horses was itself a notable coaching pub where coaches would stop on their way to all points of the compass. Now, with the new name, The Coach House is open and continues to sit proudly on Chester's Market Square near the impressive Town Hall. I suppose it is what can be called a gastro pub with a highly regarded restaurant.

The Shropshire Arms

This large and comfortable pub sits in the Market Square, Northgate Street on a plot that has had a pub straddling it for at least 300 years. The names of these ancient watering places were The Crown in 1741, the Mitre Tavern in 1817. The Crown & Mitre is shown in my 1828 *Pigot's* as having Robert Williams as the landlord, and by 1865 the pub's name had been changed to The Liverpool & Shropshire House, to try and take advantage of the passengers on the regular canal service from Chester to Liverpool and elsewhere along the Shropshire Union canal. The landlord during most of this time and when it underwent another name change to The Liverpool & Shropshire Inn was one John Lowe.

Very soon after this date it was rebuilt in the Cheshire Black and White that we see today. In 1914 as the city and country were about to be thrown into the mincing machine that was the First World War, the pub was known as The Shropshire Arms and the man to take the helm during those dark days was Joseph Walton. Our final tracing of the old landlords bring us to 1934 when John Newnes was behind the bar.

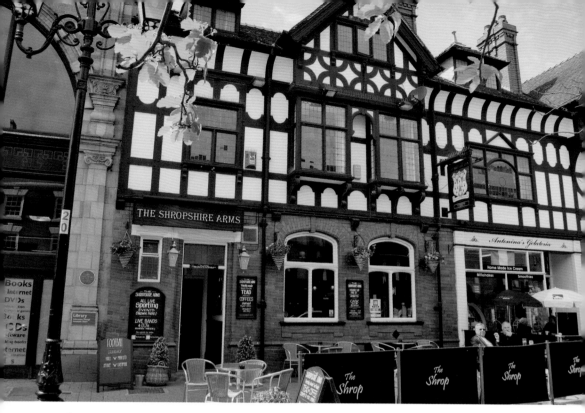

Above: The Shropshire Arms.

Below: The interior of The Shropshire Arms.

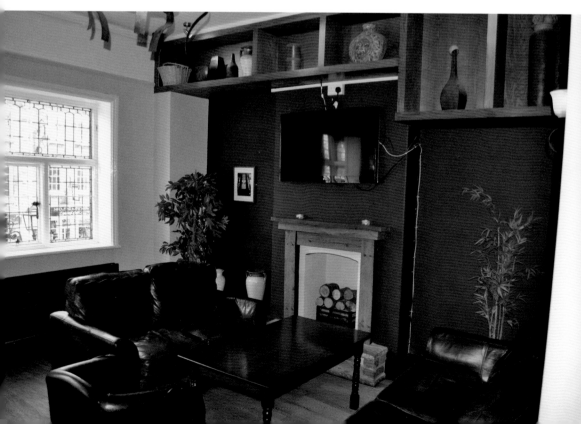

The Shropshire Arms now is an attractive pub in an attractive setting that sells real ales, has real music and an outside pavement for those sunny days in the city. From here you can watch the ancient-looking Chester Omnibus collect its passengers for a guided tour of the city.

The Pied Bull

Now we have reached probably the oldest continuously licensed pub in Chester that was built somewhere during the thirteenth century as a mansion house going by the name of Bull Mansion. The land to build it was given to the Nuns of St Mary and dwelling houses were built here in 1267. It has a hand-made staircase dating back to 1533 when it was rebuilt and became the home of The Recorder of Chester. Around twenty years later it became an inn and was called The Bull Inn, reflecting the existence of the cattle market or Beast Market outside the nearby Northgate which was later changed to The Pied Bull, and became one of Chester's important coaching inns. It remains on what was the extensive Lorimers Row but that now only stretches from The Pied Bull to the Blue Bell. In 1660 it was largely rebuilt and then again in the mid-1700s when it received the brickwork style that we see today, although it is still a timber-framed building dating from the year that it was built. In 1828 it was recorded as a hotel with Mr Thomas as the landlord. It is filled with period charm and has been tastefully and carefully modernised through the years. The staircase dates from 1533.

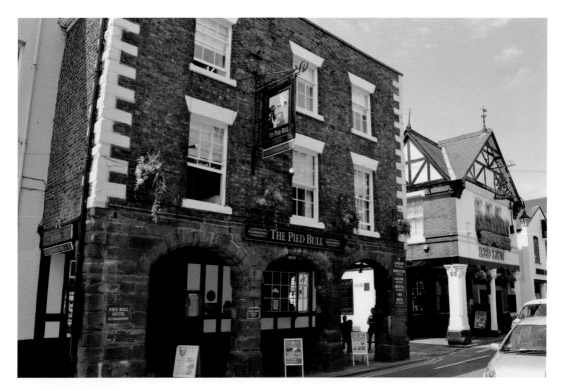

The Pied Bull.

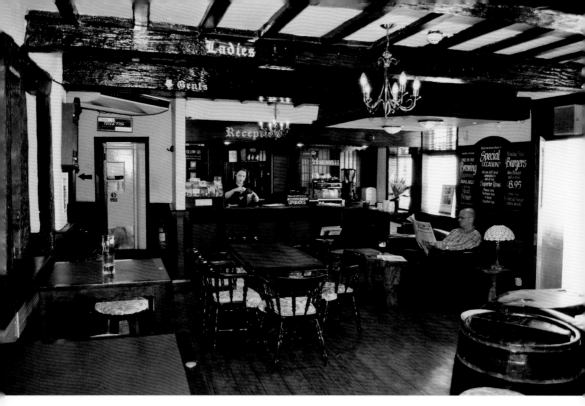

The interior of The Pied Bull.

The Pied Bull is now popular with 'real ale' drinkers as it now boasts its own 'Micro Brewery' serving its own award-winning selection of ales, Oh, and it's also quite famous for having a resident ghost; most old pubs have such an entity but The Pied Bull's is a better known one, well, two actually, a cellar man and a chamber maid.

The Blue Bell Inn

Also on the same row is possibly the oldest domestic structure in Chester. The Blue Bell Inn at Nos 63–65 Northgate Street dates back to the late fifteenth century but could very well be far older. The braced roof points to a construction date of the present building of between 1250 and 1400 although parts of the building may date back to the eleventh century. It formed part of Lorimers Row, an ancient group of buildings with an arcade at ground level. A lorimer is a Scottish word meaning a maker and seller of spurs and horse tackle made from metal. The first licence to serve alcoholic drink was issued in 1494 making it the oldest surviving example of a medieval inn. If you look at the next photograph you will see a small hole in the upper part; this was level with the top of carriages and was used to sell tickets to those riding there. The name Bell could relate to the closeness of the pub to the Abbey and the 'curfew bell' in the bell-yard. The bell was rung to warn 'strangers' to leave the city before the gates were closed at 8 p.m. Successive councils had proved unwilling to spend money on conservation. In 1959, for example, the corporation announced that the building was in such a poor state that it was to be pulled down. The ensuing campaign ended when

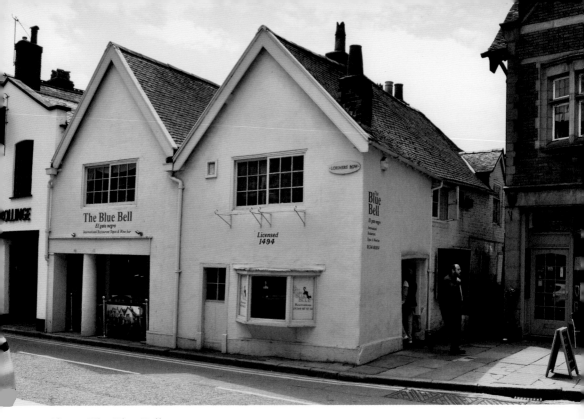

Above: The Blue Bell.

Below: The interior of The Blue Bell.

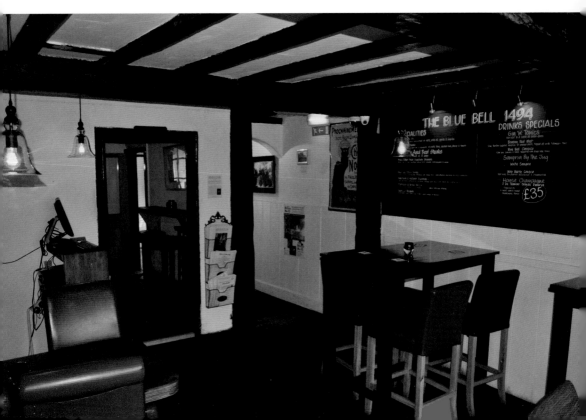

the government refused to permit demolition, and in the early 1960s the corporation had to spend £2,500 on preserving the building. This ancient pub has the pavement running through the ground floor of the building, which originally consisted of two medieval houses that were joined together in the eighteenth century. Thanks to that fight, it is still there now, has not fallen down and is a successful tapas bar and restaurant. It now goes by the name of the 1494 at The Blue Bell and is a first-class international tapas bar and grill.

The Red Lion

In the 1792 *Chester Directory* there are recorded around 140 inns and then in 1858 local author and historian Thomas Hughes recorded thirty-six trading in Northgate Street alone. He described them as being 'as plentiful as blackberries'. One of those pubs that he was referring to was the Red Lion which is another ancient pub on Lorimers Row and next door but one to The Bluebell, not quite as old as the Blue Bell but dating from around 1600 all the same. Over the years it saw alterations to the fabric and was clad in Chester's favourite, mock Tudor; in 1829 the landlord then was William Speed. The Red Lion is the most popular pub name in the country but in this case, the name was changed for a while when it became an Irish-themed pub by the name of Scruffy Murphy's but in 2001 it reverted to The Red Lion. This pub is also reputed to have a ghost haunting the cellar as to be fair has the Pied Bull and the Blue Bell. It is now a very popular pub with real ale and good food.

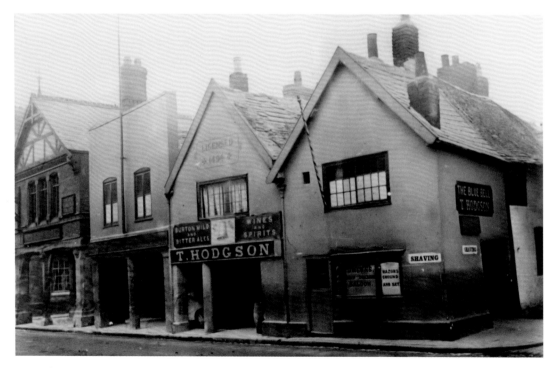

The Red Lion and Blue Bell.

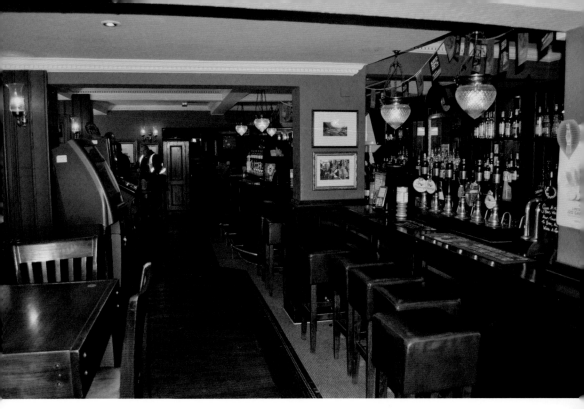

The interior of The Red Lion.

The Liverpool Arms

Continuing to the Northgate we find on the corner the Liverpool Arms, now known as the 'LA'. A successful 'gay friendly pub'. It is recorded in my *Pigot's directory* for 1828 as having William Towers as the landlord and at this time it was known as The Liverpool Arms but by 1857 it was name as The Liverpool Arms & Commercial Hotel. It is just beside the Northgate, once a very busy part of the city. The present Northgate is on the site of the original northern Roman entrance to Chester city. During the medieval period it was re-built and consisted as a simple rectangular tower but this was later greatly expanded and also became the site of the local gaol where prisoners were kept in the most basic of accommodation to await their fate. Then in 1810 the noted Chester architect Thomas Harrison added the rebuilding of the gate to his many projects in Chester and elsewhere. Behind the Liverpool Arms could be found the large Northgate Brewery which was founded in 1760 at the Golden Falcon Inn. This inn stood close to the Northgate and it was first recorded in 1704 and for many years considered the principal coaching inn of the city but by 1782 it had become a doctor's surgery. A new brewery complex was built on the site in the 1850s and the Chester Northgate Brewery Co. Ltd was registered in March 1885 as a limited liability. The company acquired Salmon & Co, wine and spirit merchants, Chester in 1890 and the Kelsterton Brewery Co. Ltd, Kelsterton, Clwyd in 1899 with 93 licensed houses. By 1891 the company owned 21 tied houses in Chester and numerous others within a radius of 15 miles from the city. It was the only Chester brewery to survive beyond 1914. In its turn, it was

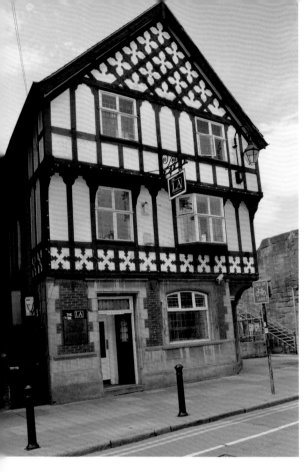

The Liverpool Arms.

acquired by Greenall Whitley & Co. Ltd in 1949 with about 140 tied houses. Brewing ceased in 1969 and it was demolished in 1971. Meanwhile, the Liverpool Arms or 'LA' continues to serve its customers with a selection of real ales, spirits and regular music.

The Boot Inn

Returning to Eastgate Street and another truly ancient pub – The Boot Inn – which first opened as an inn during 1643. It is on the level of the upper row and has two storeys, the second storey has a bay window that extends out across the street. Although it has been refurbished over the years, most of the antiquity is still present. The cellar of the pub is below street level with a barrel vault. The walls of the barrel-vaulted stockroom are medieval, the interior is very original and the view from the pub is supposedly the only pub from which a view of the Eastgate Clock can be gained. But, let's look at some of the history of this central Chester pub. It was built in 1643 from ships' timbers from the boatyards in the old port of Chester and accordingly is one of the city's oldest buildings. A lot of the ancient buildings from the Stuart and Tudor times in Chester are built from the 'ribs' that came from ships in the port as they were scrapped. During the English Civil War and the siege of Chester during 1645 and 1646 when the pub was nice and new it was used a meeting place by the Royalist troops and when Cromwell's troops invaded the city they entered The Boot and shot those in there. During Victorian

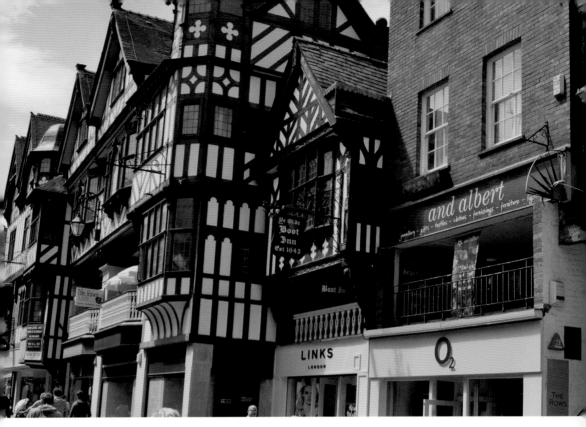

Above: The Boot Inn.

Below: The interior of The Boot Inn.

times the pub was used as a brothel. In those days the front of the pub was a barbers shop and a 'madam' organised the 'ladies of the night' at the rear. During the 1920s a gambling club was opened in one of the rooms.

The pub was extensively restored in the 1980s when a time capsule from 1882 was found containing a copy of the *Cheshire Observer*. Also found during the 1986 restoration and now on display behind the bar is a small stone ball that was found embedded in one of the ancient oak beams. This stone is believed to be a piece of ammunition from a smooth-bore gun that could either belong to the aforementioned Civil War period or even later fired from a gun used by poachers. Also in the pub can be seen exposed an area of the wattle and daub that went to make up the interior walls. This was made using a woven lattice of wooden strips, or thin branches called wattle that is daubed with wet mud, animal dung, straw and such like before being painted or lime-washed.

The Falcon

Now into Lower Bridge Street and I may have featured this famous pub in other books on Chester but it would be remiss of me not to mention it in a book on Chester's pubs. This shows a modern photograph. I was however denied permission to take an interior photograph of this ancient and interesting pub. The Falcon gives a later insight into this area in the thirteenth century when it was rebuilt, which lasted until around 1642.

The building started life as a house in about 1200 and was later extended to the south along Lower Bridge Street, with a Great Hall running parallel to the street. During the thirteenth century it was rebuilt to incorporate its portion of the row or

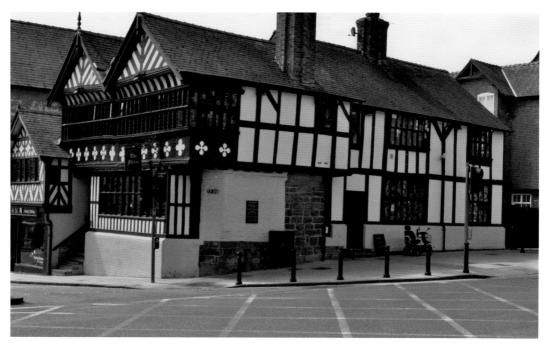

The Falcon.

walkway that was added through the front of the property. It was rebuilt again during the late sixteenth and early seventeenth centuries, and in 1602 it was bought by Sir Richard Grosvenor who extensively altered it some forty years later to make it his townhouse. During the Civil War he moved his family here from his country home, Eaton Hall. In 1643 Sir Richard petitioned the City Assembly for permission to enlarge his house by enclosing the portion of the row which passed through his property. This was successful and it set a precedent for other residents of Lower Bridge Street to enclose their portion of the rows, or to build new structures which did not incorporate the rows. As a result that street no longer has rows unlike the rest of the city centre. In the late eighteenth century the building ceased to be the townhouse of the Grosvenor family although it continued to be owned by them.

It was first used as an inn in 1778 with the name The Falcon Inn. Then around 100 years later it was restored by the famous architect John Douglas and at this time the Temperance Movement was popular in certain quarters and The Falcon became the Falcon Cocoa House serving only non-alcoholic drinks. Through the 1960s the pub lay empty and derelict but it was later restored by The Falcon Trust and reopened as one of Chester's ancient and popular watering holes.

Oddfellows Hall

As we continue down Lower Bridge Street we come to a large and impressive Grade II-listed building that is now an attractive boutique hotel and bar. It was built in 1667 for Lady Mary Calverley and was originally called Bridge House, a large neo-classical

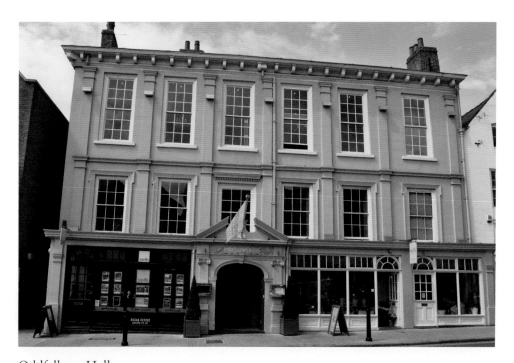

Oddfellows Hall.

townhouse. She made a name for herself as one of the residents in Lower Bridge Street to petition the City Assembly for permission to demolish the original house that contained a section of the Chester Rows and replace it with a new house. This was granted and during the rebuilding, like The Falcon, the rows were incorporated into the building. She was fined £20 for this illegal act (this would be around £3,000 now). During the eighteenth century the house was occupied by a local attorney-general by the name of John Williams and since that time it has been used for various purposes that include a school, a club, offices and shops. In the later part of the nineteenth century a second bay was added and then later, the ground floor was projected forward to incorporate a row of shops. All of this change culminated in what is there now: a beautiful building and smart hotel that markets itself as a fantastic bar located in the centre of Chester. It is an extremely stylish and well-presented bar that caters for all guests where bar tenders entertain with their cocktail-making skills with music just as you like it and a choice of champagnes, fine wines and beers from around the world.

The Brewery Tap

Continuing down Bridge Street we reach a new pub in an ancient building at Nos 52–58 Lower Bridge Street. Set back from the road up a short stairway this popular pub building stretches way back in Chester's history and played a very important part. Known as Gamul House the building was once a Jacobean Great Hall that had been built for the Gamul family and is the only stone-built medieval hall to survive in Chester. This family were very wealthy merchants in the city and powerful enough to support their own army. This army was lent to Charles I who stayed here from the 23–26 September 1645. This area was in the very early days a Scandinavian settlement. The church opposite is St Olaf's, a church dedicated to a Norwegian saint martyred in 1030. This church is the oldest building in this ancient street.

Parts of the present Gamul Hall date from around the early sixteenth century with the oldest visible areas being the wall and fireplace behind the bar. In those early days most buildings were built of wood with manure and mud infills. After such fires as the Great Fire of London, local councils stared to look at this use of wooden structures. It was after this that the medieval façade of Gamul House was changed for a brick-built one, not quite as attractive but a lot safer. Lower Bridge Street lost most of its rows after the Civil War and perhaps the owners of the present Falcon did not help in applying successfully to incorporate their row into the building an incentive taken up by other owners in the street. In fact the raised walkway in the front of The Brewery Tap was once part of the row.

As for the Gamul family, they lived here during the sixteenth and seventeenth centuries. Thomas Gamul was the city's recorder and his father was mayor on four occasions. His son Sir Francis was a staunch Royalist and resided here during the Civil War, he was responsible for the cities defences and the last time that Charles I stayed was the night before the Battle of Rowton Moor or Rowton Heath, and it was from here that he will have made the short walk to the walls of Chester to watch his army lose decisively to the Parliamentarians. The king made his escape across the old Dee Bridge and into Wales. He was imprisoned and executed in January 1649. Chester was

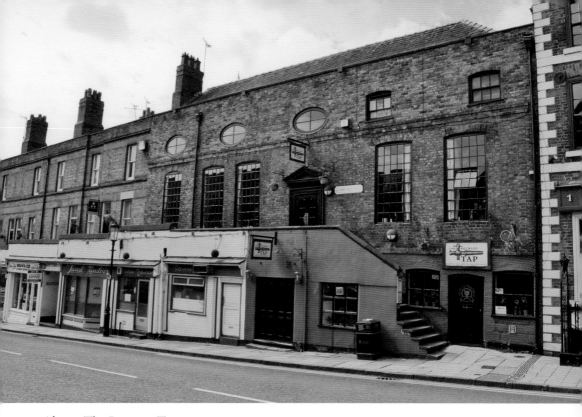

Above: The Brewery Tap.

Below: The interior of The Brewery Tap.

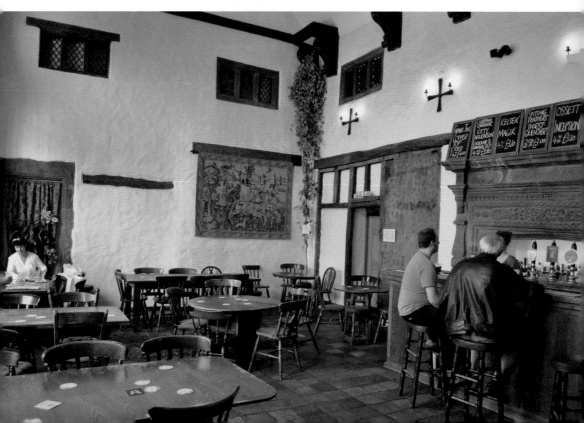

badly damaged during the siege that followed and this was exacerbated by the onset of a huge outbreak of the plague that killed nearly 2,000 people. Being on the losing side, Sir Francis had his lands seized by Parliament. The family tomb is at St Mary's Centre, once St Mary's On The Hill at the top of the road, now as Chester's Heritage Centre. Over the years Gamul House became run down; when Nicolas Pevsner inspected it in the 1960s he reported that it looked derelict. Chester City Council then took it in hand, bought it and in the 1970s started a full refurbishment. On the fireplace behind the bar is a painting of the coat of arms of the Gamul family. Historian Pevsner identified this as being executed by the historian and heraldic artist Randle Holme.

On the 20 November 2008 it was opened as The Brewery Tap selling locally brewed ale from the Spitting Feathers brewery. This brewery is located at Waverton on the outskirts of Chester that just happens to be near the famous battlefield of Rowton Moor.

Ye Olde King's Head

Further down we find another ancient watering hole, Ye Olde King's Head Hotel. This is on the junction of Lower Bridge Street and Castle Street, the street that leads up to the castle and it was constructed in 1622 for Peter Clerk, the administrator of Chester Castle. The foundations date back to the early 1200s and the front elevation can be

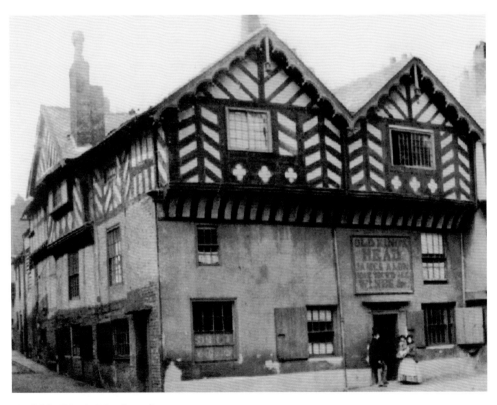

Ye Olde King's Head, early 1900s.

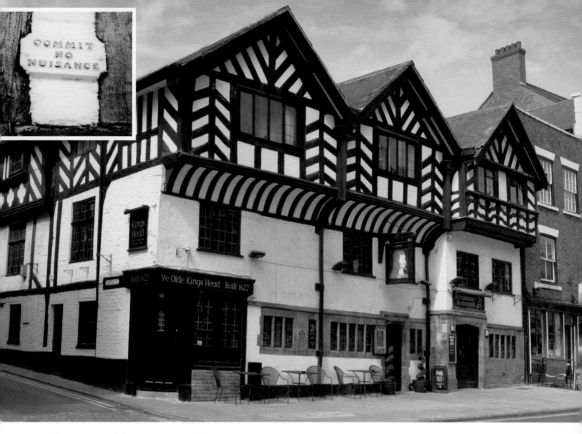

Above: Ye Olde King's Head, 2015.

Below: The interior of Ye Olde King's Head.

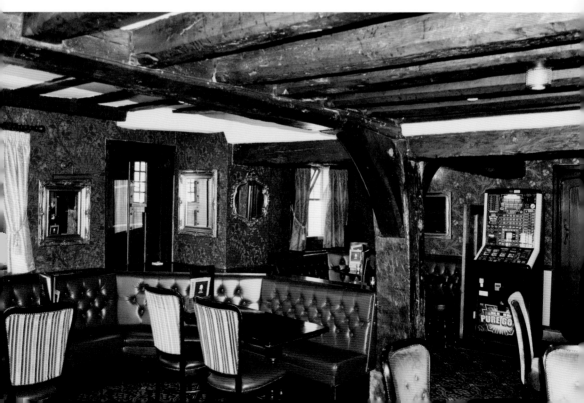

dated back to the seventeenth century and it first became a pub in 1717. As already mentioned in relation to other buildings in Bridge Street, it once contained a section of the rows but these were closed during the early eighteenth century. The latest of these alterations were made for Randle Holme the Chester historian and first Mayor of Chester from 1633 to 1634 and was described at the time as a 'new building'. The building was also restored in 1935 and again during the 1960s. The pub still boasts an Elizabethan fireplace. Staying next door at Gamul House was Charles I and it is believed to have been at this time, the 1600s, that the pub received its name. On the side wall in Castle Street is a rather unique iron plaque that warns people to 'Commit No Nuisance'. This pub stands in one of the reputedly most haunted cities in the country and Ye Olde King's Head is supposed to be one of the most haunted buildings.

The Bear and Billet
A few doors down from Ye Olde King's Head can be found another of Chester's best known pubs, the old Bear and Billet, a pub that has a chequered history but still retains the ambience of old. It was built in 1664 and this date is prominently shown on the front elevation. It is one of the last wooden buildings built in the city and it was built as the townhouse for the Earl of Shrewsbury who was at the time one of the Serjeants of the Bridgegate. This entitled him to collect tolls from people passing through the nearby Bridgegate. In 1820 General Grosvenor was thrown from the Dee Bridge into the river by his political opponents as he was crossing in his carriage and he was given help and safety at the pub. It was at one time known as The Bridgegate Tavern.

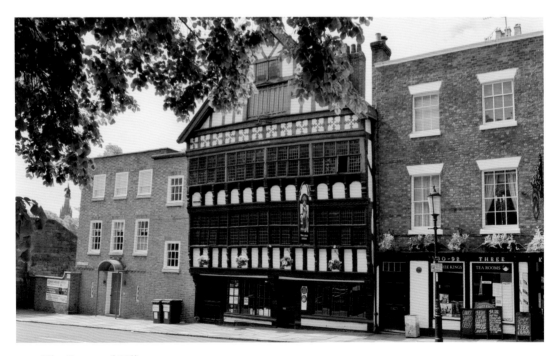

The Bear and Billet.

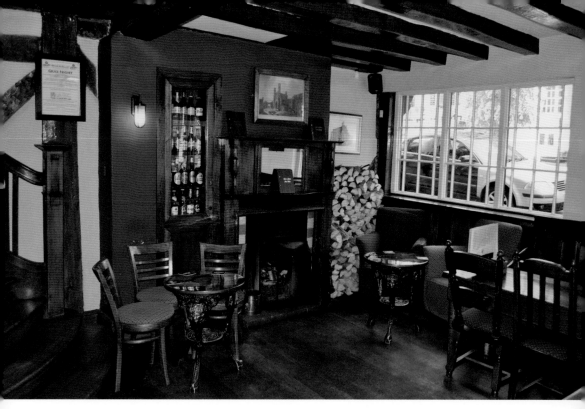

The interior of The Bear and Billet.

It is recorded as a Grade I-listed building and has been described as 'the finest seventeenth century timber-framed townhouse in Chester and one of the last of the great timber-framed townhouses in England', its name is taken from the heraldic device on the arms of the Earl of Shrewsbury that consists of a bear tied to a billet or stake. John Lennon's maternal grandmother Annie Jane Milward was born at the pub in 1873 and lived there until she was in her twenties. The Bear and Billet is, as previously mentioned, listed as Grade I, but this did not stop it being refurbished in 1999 and renamed Bensons At the Billet in 2000. The locals were not happy about this and a year later it reverted to The Bear and Billet and is still serving the public under its ancient name. Like other pubs in this street, walking through the door is like walking back to a time of dark wood, old-fashioned glass windows and the ambience of another era.

The Cross Keys

Across the road from Ye Olde King's Head on the corner of Duke Street we find the Cross Keys. Closed for a while and now opened and in the Joules Brewery chain selling real ales from their own brewery in Market Drayton, Shropshire. The pub was built in 1894 and is quite beautiful inside and out. The brewery have, during refurbishment, installed their own specially commissioned stained-glass windows. They have a newly refurbished function room with its own name, The Slaughtered Lamb. The name Cross Keys has featured in other older Chester pubs through the years but this one remains,

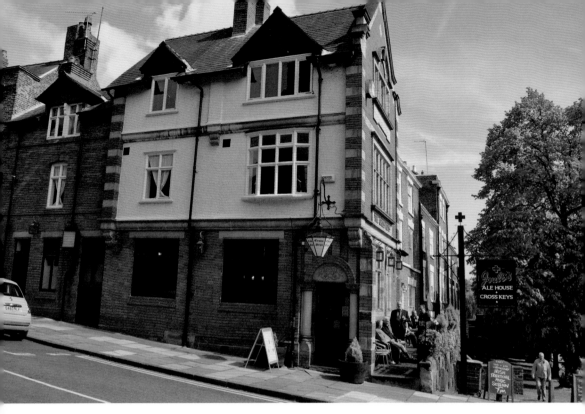

Above: The Cross Keys.

Below: The interior of The Cross Keys.

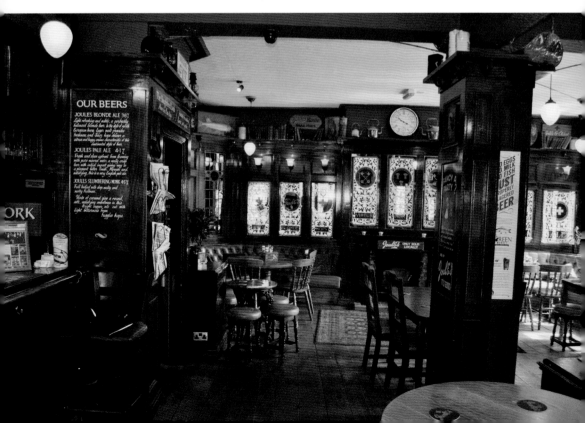

once again welcoming customers. The name Cross Keys comes from the bible as Christ gave St Peter the keys to the kingdom. It is a commons sign in Christian heraldry including the papal arms that also feature crossed keys. Probably one of the best and most tastefully refurbished pub interiors anywhere.

Back up to the top of Lower Bridge Street and into Grosvenor Street, now part of the Inner Ring Road and as we walk towards the Grosvenor museum we find a very picturesque pub that has just reclaimed its old name.

The Saddle Inn

We have arrived at an attractive pub with the horsey name The Saddle Inn. This hostelry could once be found in Bunce Street but after that one was demolished it was rebuilt in Grosvenor Street. This pub does not appear in my 1829 *Pigot's directory* but by 1880 it is there and the landlord is August Bernhard. In 1996 the pub name was changed to The Chester Bells, a rather strange name change in view of the fact that the pub is very close to the Roodee and a favourite of race-goers. During 2014 it underwent a £250,000 refurbishment and the original name returned. The exterior is very attractive in a Tudor revival style, in keeping with the surroundings and with the

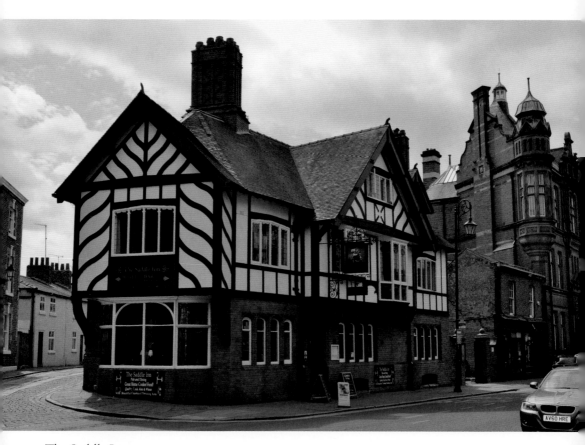

The Saddle Inn.

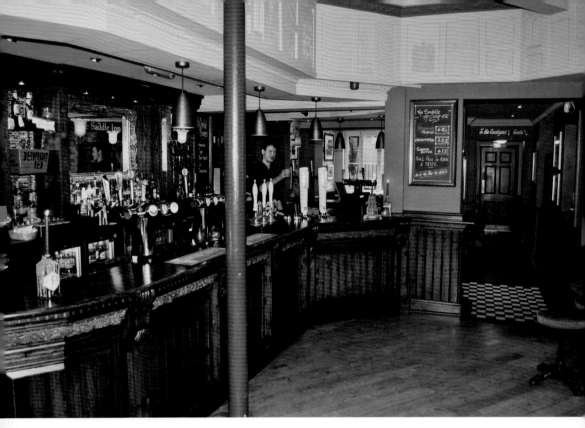

The interior of Saddle Inn.

Grosvenor museum nearby. I believe that it is now in the same stable as The Victoria at The Cross. The pub has a good reputation for food and for those seeking a bed for the night, there are nine ensuite rooms with all the trimmings.

The Golden Eagle

Now better known simply as The Eagle, at No. 16 Castle Street, this pub is situated near Chester's Crown Court. The building was built in the fourteenth century as a house and the Sherriff of Chester once lived here. Over the years it has welcomed soldiers from the nearby barracks and the staff of the Crown Courts. The pub was closed for a while until 2012 when it was taken in hand by a new owner. It has now been modernised, leaving it in a minimalist style but with plenty of original features including dark wood and wooden floors. It is what I would call a proper boozer with accommodation and food, good service and good music. The original front elevation was white but now it is grey and black, an acquired taste, I suppose! It is reputed to be one of the friendliest pubs around. In 1915 the pub was perfectly situated to serve the troops who were to leave and hopefully return to the nearby militia barracks. The war was about to start and Catherine A. Hunter was the landlady.

Before we leave our pubs that are still trading within Chester's walls, let's have a look at some of the more modern pubs.

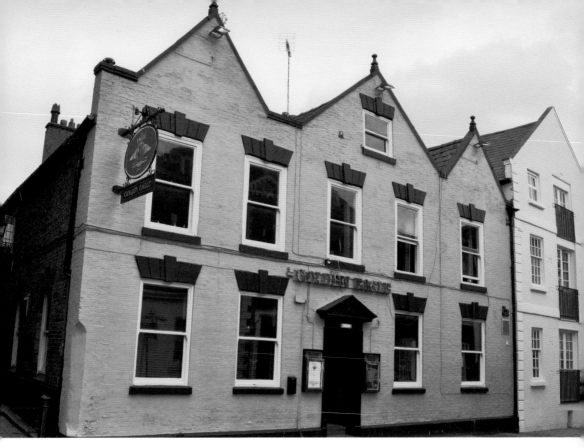

Above: The Golden Eagle.

Below: The interior of Golden Eagle.

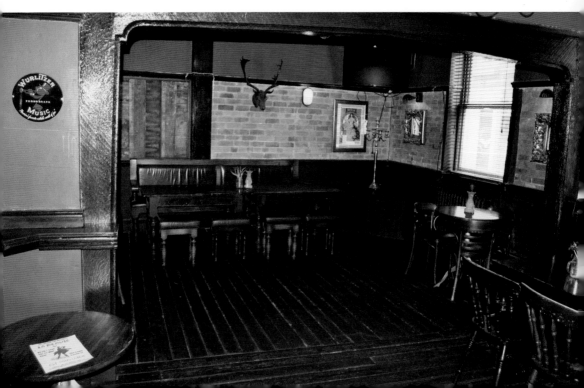

Dutton's Wine Bar.

Dutton's Wine Bar

Werburgh Street runs from Eastgate Street past the cathedral and into Northgate Street but half way along opposite the noble cathedral we see what is no more than an alleyway. This is Godstall Lane and within its boutique-like walls you will find Dutton's Wine Bar. It is situated in an area dripping with antiquity mixed with modernity, where the thirsty tourist can sit at tables on the pavement and enjoy a drink or a meal. I would describe it as probably the nearest thing to continental à la carte dining as can be found anywhere in the city. Not just a restaurant but a quality pub; I suppose you would call it a bistro bar, and it is now owned by Lees Brewery of Manchester.

Alexander's Rufus Court

Alexander's is situated in Rufus Court which is off Northgate Street opposite the ancient Blue Bell. It was established in this modern court in 1991 and is now described as the leading North West venue for music. This includes jazz, blues, soul, roots and rock. Also on offer are comedy and drama. Every Saturday night there is an alternative comedy spot and this means that Alexander's calls itself the longest-running comedy club outside London. A club like this is all about ambience where the customer can book a meal and sit at a table near the stage and close to the performer as in days of old, when our forefathers were entertained in the original cabaret lounges.

Bollicini Bar and Restaurant

Staying in the small select Rufus Court we find an Italian restaurant and bar called Bollicini. The idea for the bar comes from the fashionable bars and restaurants of Milan, where authentic Italian cuisine, cocktails and quality service are to be found. The authenticity continues as we find out that it is run by Italians keen to give their customers a true, authentic experience of Italian cuisine. There is a full à la carte menu available as well as a special lunch menu and Sunday specials. Then there is the Bolli Bar where cocktails are a speciality and you are welcome to watch your drinks being blended, shaken or stirred. A range of Italian wines and beers is also available.

Back now to another well-known Chester pub. In these days when pubs are closing or being turned into gastro pubs and given names like The Ferret and Trouser Leg, it's nice to see a pub that has remained unchanged for most of its life. And I mean unchanged, this is a real ale house, boozer or whatever you like to call a real drinking pub, now with good wholesome food.

The Albion

The Albion in Park Street was in 1860 a pub and brewery owned by one Henry Knight who was a brewer and maltster. He was there in 1896 when he was still recorded as a brewer. But as the years passed, the first of the long-standing landlords took over and

The Albion.

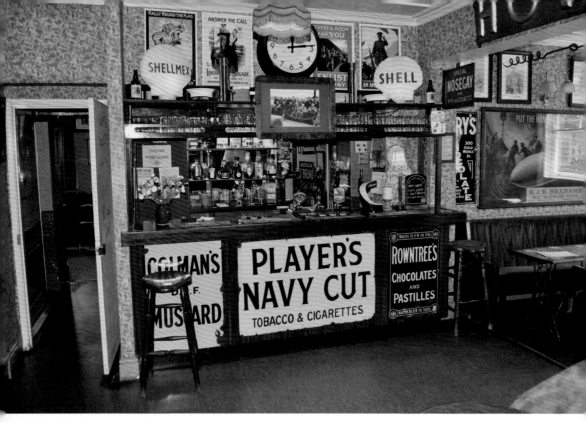

The interior of The Albion.

that was a gentleman by the name of Jim Carter. It is a tradition in some parts that the name of the landlord would supersede the name of the pub and although still called The Albion it became for a while better known locally as Carter's.

Mr Carter was 'mine host' during the 1960s as this typical old pub was handy for the tourists who walked the walls that overshadowed it. Forty-two years ago Mike Mercer took over and the pub became even more unique, when Greenall's expanded it into the house they owned next door, Mike ensured that the unique ambience would remain with the addition of much First World War memorabilia and old advertising signs. The inside is a veritable museum and probably one of the most original English pubs in the country. Children are not permitted and as in the 1960s the pub closes every afternoon. Sitting below the Walls and having nearby the former Drill Hall where recruiting took place prior and during the war, Mike points out that many a young lad on his way to the mincing machine that the war became would spend his King's Shilling at the bar of The Albion. Still sitting below the city wall in Park Street, a warm welcome awaits at this old-time watering hole. Whether it's for a drink, a meal or a room for the night, you will be made welcome.

Chapter Two

Chester Pubs Within the Walls that Have Now Gone or Left the Brewing Trade

Using the Eastgate Clock as our central boundary, we return to Bridge Street. Turn from The Cross into Upper Bridge Street where we soon find a narrow road called Commonhall Street and some well-known pubs of old that have now been taken from the trade.

Ye Olde Vaults.

On one side of the entrance to Commonhall Street we find Ye Olde Vaults, better known for over a century as Barlow's after a long line of family landlords. Dating back to 1789, it used to be one of the most popular meeting places in Chester for many generations. Married and courting couples would meet in the lounge at Row level and as a result this became known as The Passion Parlour. The bar at street level was where the locals and the more mature patrons would gather. At the rear there were two small cosy rooms with surrounding seats in deep red leather-like material. On the walls were finely framed pictures of old Chester. The whole place had a wonderful atmosphere and character totally lacking in most modern pubs. This did not prevent the owners from closing it down in 2002.

Opposite, on the other side of the Commonhall Street entrance, is a building once known as The Grotto Hotel. In the 1781 Cheshire directory the pub was known as The Harp & Crown and the landlady was Mrs Doughty. By 1876 the landlord was Ebenezer Jones. By 1919 the pub's name had been changed to The Grotto Hotel and the landlord was J. Ingoldsby. It is now a shop. Now crossing Grosvenor Street look to our right to an area that once had a large and impressive pub sitting at the junction of Grosvenor Street, Whitefriars and Bridge Street.

The Grotto Hotel.

King's Head Hotel

Here we once found a hotel going by the name of the King's Head. The hotel was built in the very early 1800s and remained a popular pub and hotel until 1986 when the powers that be decided to demolish it and build a large mock-Tudor office block in its place that has been described by various historians as a 'Lego' building, See what you think with this selection of before-and-after photographs of the area and the hotel. There was a pub on this site previously called the White Horse and later The Horse & Baggs but this may have been prior to the building of this King's Head. My *Pigot's directory* for 1828 gives the tenant as William Posnett. Enjoy a bit of old Chester that has gone forever with the photograph overleaf of Grosvenor Street with the King's Head on the far right. The date is 1960 and the photograph is filled with period charm. Then it is back to Grosvenor Street to the junction with Cuppin Street.

The photograph overleaf of Grosvenor Street at the junction with Cuppin Street shows in the 1902 photograph the Fox & Barrel public house, at the time Mrs Elizabeth Jones was the landlady, probably the lady in the photograph. The pub walls are adorned with posters offering 'Cycles stored and good stabling'. The building was much altered over the intervening years and went on to be a kitchen showroom and a motor-scooter dealership. It now houses a Brazilian Steakhouse.

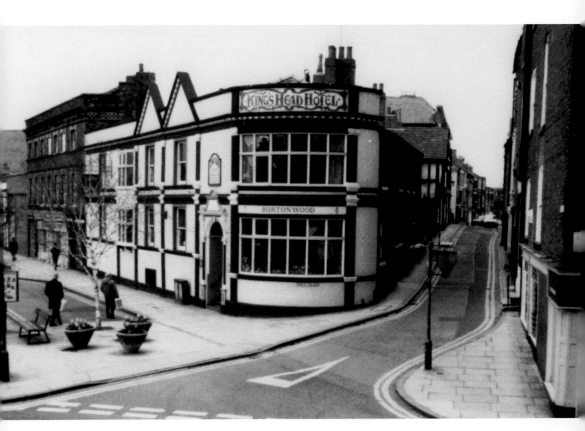

King's Head Hotel, *c.* 1980s.

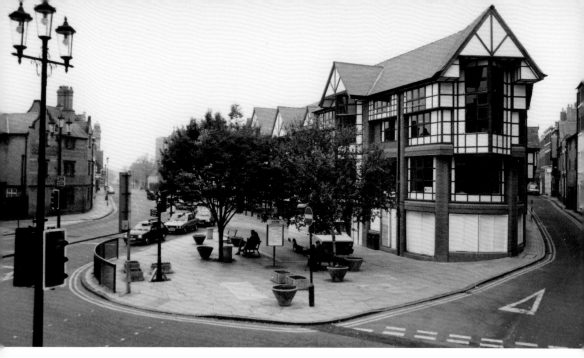

Above: King's Head Hotel, 2007.

Below: A look up Grosvenor Street.

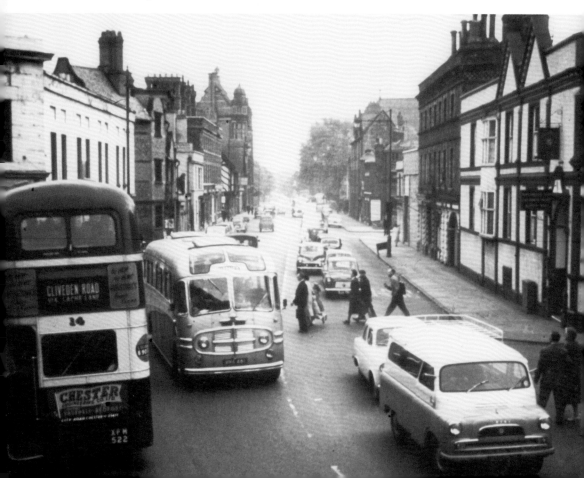

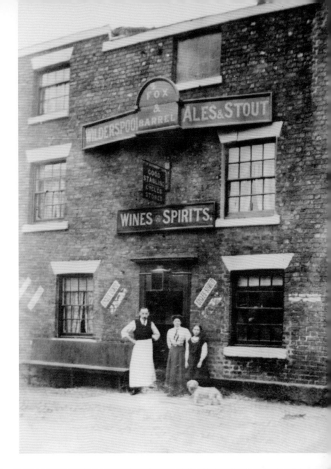

Right: The Fox & Barrel, 1902.

Below: Tropeiro, 2015.

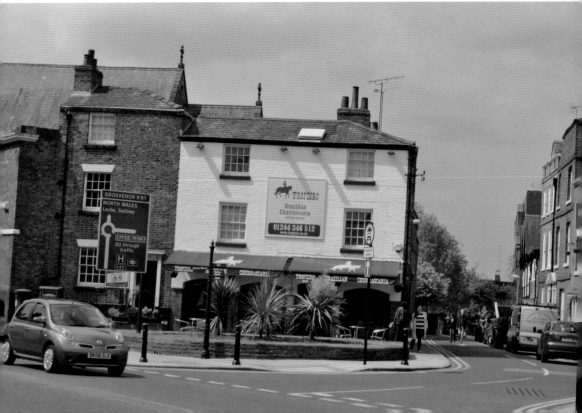

The Red Lion

Although no longer with us, the old Red Lion at the top of Lower Bridge Street is worthy of a mention. The photograph below dating from the 1960s shows the pub just before it was demolished and a large office block was built on the site. The Red Lion Inn (later Hotel) dates back to 1642 at No. 7 Lower Bridge Street, near the junction with Pepper Street, and across the road from St Michael's Church, now Chester History and Heritage centre. On the other side of the road is the even older Falcon Inn. In November 1771, one John Mainwaring a retired butler, let it be known that he had taken 'the old and well-accustomed inn, the Red Lion'. It was at one time one of numerous pubs belonging to the Chester Northgate Brewery. The Red Lion was listed in Cowdroy's Directory in 1789 when the landlord was William Hancock. For over 300 years, the inn occupied a set-back site at the top of Lower Bridge Street until the alterations which turned Pepper Street into Pepper Row and the Inner Ring Road. Since then this prominent site has been occupied by the large office block called Windsor House.

My fellow author and noted Chester historian Len Morgan spoke of it as the 'notorious' Red Lion, 'the scene of many a conflict of fisticuffs, and that's putting it mildly. It was not exactly the place to take a girlfriend or go for a quiet drink'. He also added that, such was its reputation during the war that it was the only pub in Chester where US servicemen wouldn't go, and that it was carpeted throughout in red 'for good reasons!' ... The elderly couple that ran the place up to its demise in 1968 were named Swallow. Then to the bottom of Lower Bridge street to find an interesting ex-pub.

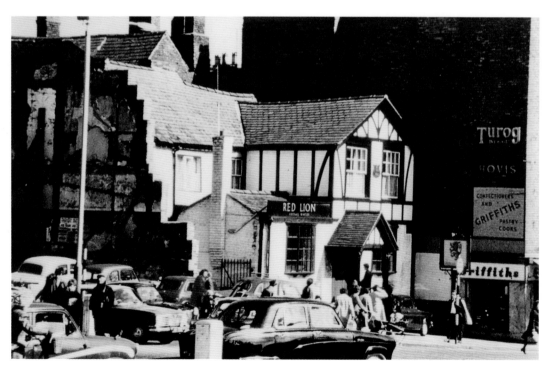

The Red Lion, Bridge Street, 1965.

Photo of the area now.

Ye Olde Edgar

Ye Olde Edgar is situated at Nos 86–88 Lower Bridge Street on the junction with Shipgate Street. The ancient building was at one time two houses when it was built in the sixteenth century and it was later combined to become an inn. For many years thereafter it was the Ye Olde Edgar, later becoming the King Edgar and The Edgar Tavern. This name comes from King Edgar who became the king of all England. In 973 Edgar of England marched his army to Chester. This was in the days when Chester had a port and his navy met him in Chester via the Irish Sea. This show of strength persuaded the northern kings to submit to him as their king. It is then reputed that he was rowed across the Dee by Kings Kenneth of Alba, Malcolm of the Cumbrians, Magnus of Man & the Isles, Donald of Strathclyde, Lago of Gwynedd and Princes Hywel of Gwynedd, Ithel and Sifert. As well as the pub name, Edgar's Field is a park in Chester. So once again we have evidence of the city's importance down the years. As for Ye Olde Edgar, after it closed it slowly became derelict. It has now been restored and is once again two houses. Then back up to St Peter's church and we walk along Eastgate Street to the famous Eastgate and its even more famous clock.

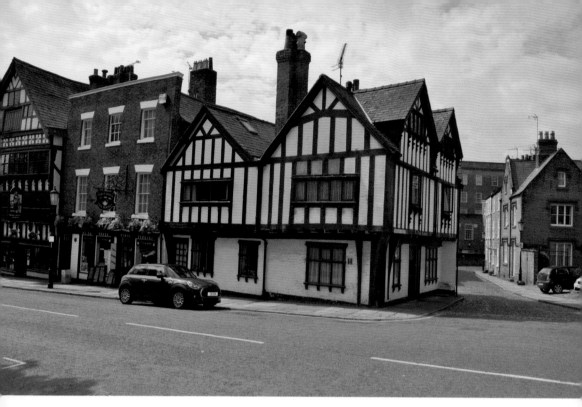

Ye Olde Edgar, 2015.

Kings Arms Kitchen

In a book on Chester pubs we cannot fail to mention another interesting pub called the King's Arms Kitchen. As you look towards the Eastgate Street clock from within the walls on the left-hand side, immediately next to the gate is a narrow passageway, at present locked with an iron door. At the end of this, there formerly existed a public house called the King's Arms Kitchen, also known as Mother Hall's. In the eighteenth and nineteenth centuries, it housed a drinking and gambling club going by the splendid name of The Honourable Incorporation of the King's Arm's Kitchen. This came about as the result of an order by Charles II that the ancient custom of electing the mayor and his officers was to end. Sir Thomas Grosvenor was appointed as mayor, thus spawning an oligarchy between Eaton Hall (the Grosvenor residence) and Chester Corporation that would last until the Election Reform Act of 1832. The city's inhabitants were, unsurprisingly, increasingly unhappy with this imposition of an unelected mayor and corporation, and one evening around the year 1770, a group of tradesmen met in a room in this pub and decided to form a City Assembly of their own, which was organised as a complete shadow assembly, a satirical imitation of the corporation, with its own elected mayor, recorder, town clerk, sheriffs, aldermen and common councilmen. They even had a replica of the mayor's sword and mace made for them. In the course of time, the serious, satirical point of the King's Arms Kitchen was largely lost and it degenerated into a drinking and gambling club. The regulars, however, did not forget the old rules and regulations, such as that which declared that if a stranger

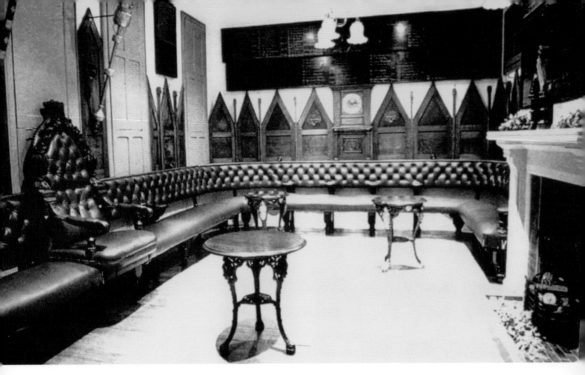

King's Arms Kitchen.

sat in the mayor's chair, it was his duty to buy drinks for all present. During the Second World War, many an American GI was invited to sit in the imposing chair only to have to buy drinks for all.

When the King's Arms Kitchen was closed in 1978 the chairs, plaques and a display of this unique pub room were removed to the Grosvenor museum where they can still be seen. Then we retrace our steps past The Cross, travelling down Watergate Street to the junction with Nicholas Street where in days of yore we would have found a pub described as 'without exception the most picturesque and curious of all our Chester inns', and the premier hostelry in the city on its most important street.' This street now forms part of the Inner Ring Road.

The Yacht Inn

Already featured in more detail in *Chester in the 1960s* and mentioned in the introduction. This ancient pub was situated in what is now the Chester Castle-bound carriageway of Nicholas Street. It was swept away when the street joined with St Martin's Way to form this leg of the Inner Ring Road in the 1960s. Both the London and Ireland stagecoaches called at its door and it was noted for its feasts, entertainments and good accommodation. The satirist and author Jonathan Swift when let down by the clergy from the cathedral used his ring to scratch on the window pane, 'Rotten without and mould'ring within, this place and its clergy are all near akin.' By the mid-nineteenth century, the old inn had fallen on hard times; in 1853 it was described as 'now reduced to very humble pretensions compared to its former character', and, a century on, had become just another street-corner pub.

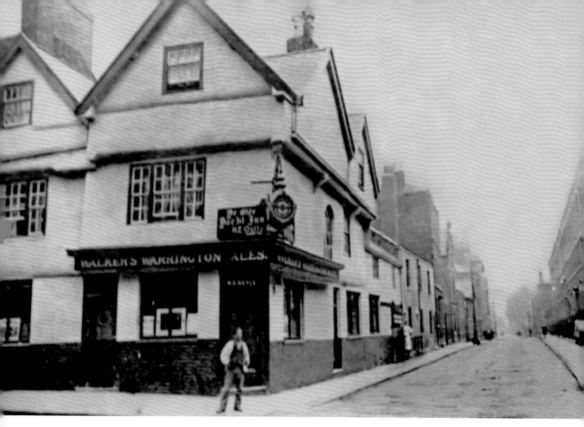

The Yacht Inn, 1920.

Chapter Three

Chester Pubs Still Trading Outside the Walls

Marlborough Arms

Situated at No. 3 St John Street and set back from the road is this small although internally long pub. The first thing that you probably don't notice is that the name is spelt wrong and should read Marlborough. This was done by a signwriter who

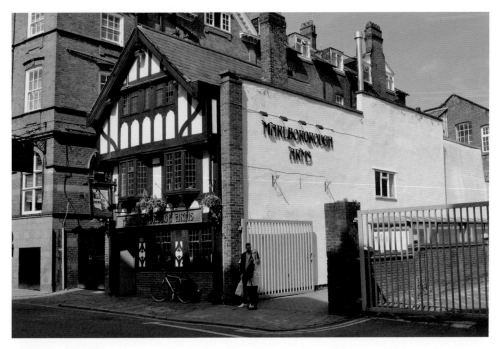

Marlborough Arms.

simply got it wrong and it was decided to keep it as it was, for fun. In 1818 it was The Duke of Marlborough, then in 1829, The Duke of Marlbro.' By 1896 it is shown as The Marlborough Arms with the tenant of this town centre pub, according to *Pigot's Directory* was John Aslett. Once attracting customers from the nightclubs in the area it is still open and trading in this city centre spot.

Off the Wall

At the bottom of St John Street and situated at No. 12 we find the modern Off The Wall pub that is situated close to the wall and the Newgate. But first the story of how it came to be there. In 1898 there were 168 subscribers to Chester's telephone service and most of them were businesses. Operated by the Liverpool and Manchester Exchange Telephonic Co. as a subsidiary of the United Telephone Co. and under post office licence, the U.T.C. merged with its subsidiaries as the National Telephone Co. in 1891. Its Chester Exchange and regional head office were in Godstall Chambers, St Werburgh Street. The exchange was transferred to a new building next to the Main Post Office in St John Street in 1908 in anticipation of the post office's acquisition of the telephone system, which took effect in 1912. It moved again in 1950 to a neo-Georgian building on the north side of Little John Street built for the purpose in 1939. But what has this to do with pubs? you may ask. Well, when automation arrived the need for a big telephone exchange fully manned, as in the first photograph, diminished and the building was sold off, becoming a public house called 'Off The Wall' and a false floor has split the once-high building into two floors. The ground floor can be seen in the modern photo.

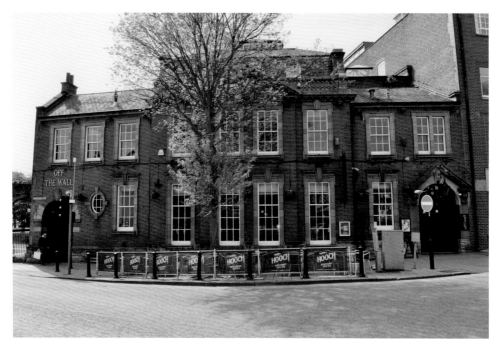

Off the Wall.

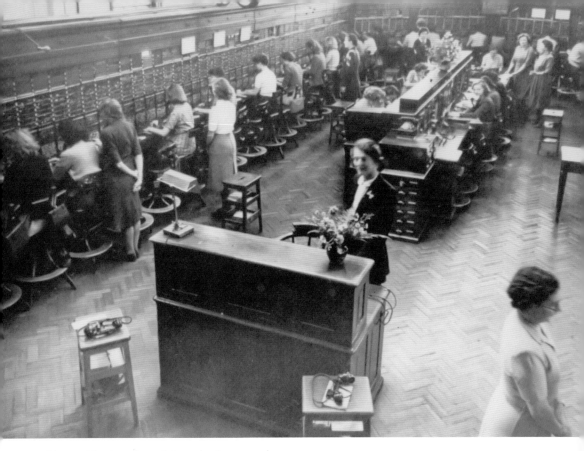

Above: The interior of the telephone exchange, *c.* 1950s.

Below: Internal, Off the Wall pub, 2014.

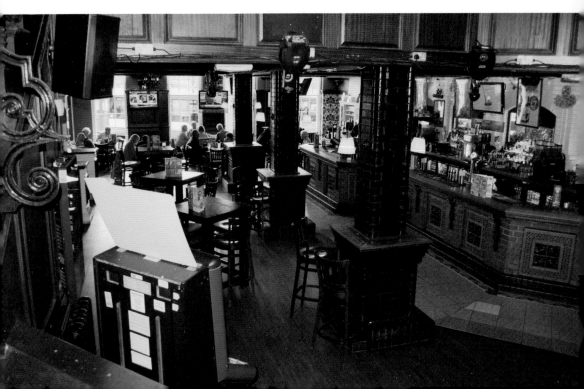

The Forest House

A new Wetherspoons pub can now be found in the attractively named Love Street in Chester. It bears the strange name for the area, Forest House, and it is situated at No. 1 Love Street. This large townhouse was originally built in 1759 although the year 1780 has also been suggested. It was as a townhouse for Mr Trafford Barnston who resided there. The house itself is one of Chester's finest surviving Georgian villas. But having referred to my massive Ormerods' *History of Cheshire* I can give you a bit of history and say that the Barnston family acquired their name from the village of Barnston on the Wirral, Hugh de Berneston being the first known member of the family, living there in 1293 and possessing land in Worleston near Nantwich. The family moved to Churton by Farndon where they resided for several hundred years in Churton Hall and by the end of the eighteenth century they had acquired this building, then known as Forest House with the address Forest Hill. In the early nineteenth century they moved to Crewe Hill House in the parish of Crewe Hill by Farndon, near Chester which was extended from an original farmhouse in the early 1800s. Roger Barnston died at the age of eighty-eight in 1837, leaving his estate to his only surviving son, Roger Harry Barnston.

This son married Selina, daughter of William Makepeace Thackeray MD of Chester. In the late 1800s Harry Barnston Esquire lived at Crewe Hill and by then probably, no longer had any dealings with Forest House. It went on to become auction

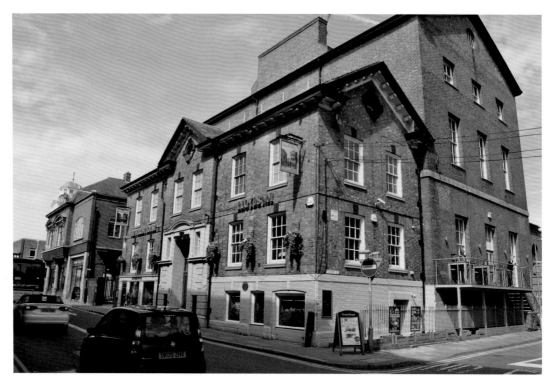

The Forest House Lloyds No. 1.

rooms and a furniture depository. Only the central block of what was once a much larger house remains and the once extensive gardens have been built upon. By 1914 that house was the home of the Chester & Eddisbury Conservative and Unionist Working Men's Club. Later it became a branch of the Co-operative Society, dance hall and in the 1970s a live music venue called Smarties. At this time acts such as Adam and The Ants performed there. Even later after extensive and sympathetic restoration it became The Mansion House; this enterprise failed and the Mansion House soon closed. Now as part of the Wetherspoons chain of pubs it seems to be doing well and is the second Wetherspoons bar in Chester; The Square Bottle in Foregate Street is still open and serving its customers.

Temple Bar

Back now to Foregate Street and into Frodsham Street where we find a pub that was once known as The City Arms. During the 1990s it was extensively 'modernised' with a theme that included a pulpit and confessional box, presumably to go along with the temple theme? These and other items of church furniture are original, having been removed from a church in Manchester. The old pulpit is no longer the place from which the vicar threatens churchgoers with fire and brimstone and tries to save their souls but where the DJ now plays his mixture of pop and rock music to the crowds of worshipers of a different kind below him. In 1828, as The City Arms the landlord was John Williams and there was another City Arms on Northgate Street. By 1914 George Jamieson was in the chair. The pub is still open and serving customers.

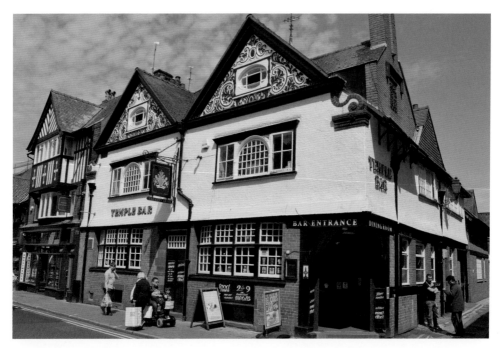

Temple Bar, Frodsham Street.

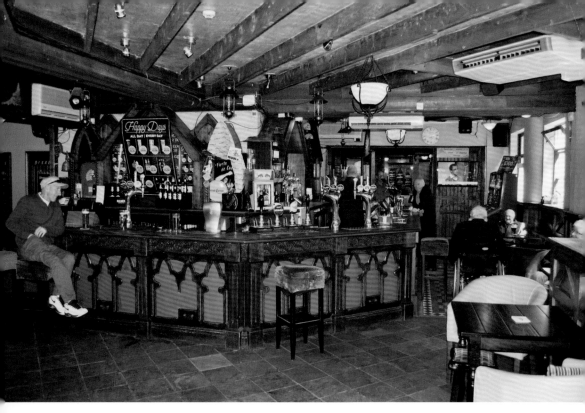

Above: The interior of Temple Bar.

Below: The Oddfellows Arms, Frodsham Street.

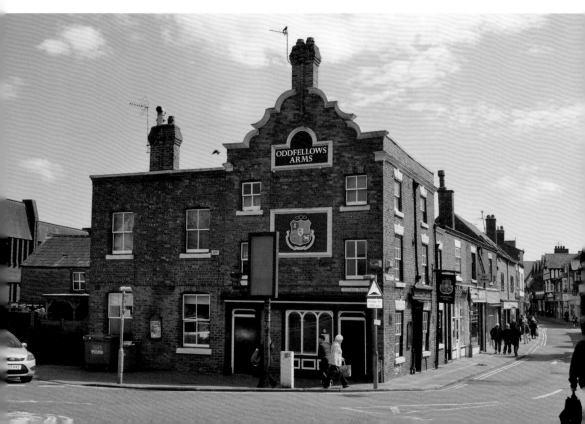

The Oddfellows Arms

Now to the bottom of Frodsham Street where we find our next pub that is still trading in its original name, The Oddfellows. It's not shown in my 1828 directory but by 1914 it is recorded as The Odd Fellows Arms and Elizabeth Charmley was the landlady, having presumably taken over from her husband who was in the job some 15 years earlier. There was also another Oddfellows Arms in Princess Street. Neither existed in 1892 so it dates the pub to the mid-1800s.

The Lock Keeper

Formally known as the Frog & Nightingale it has now been given a more appropriate name being as it is alongside the canal. This large modern pub has a very pleasant beer garden from where one can sit and enjoy the canal-side views. Situated at the bottom of Frodsham Street near the aforementioned Oddfellows Arms.

Ye Olde Queen's Head

Back now into Foregate Street where we come to another attractive black and white pub that was in the 1829 *Pigot's Directory* when Joseph Gresty was the tenant; by 1860 it was Joseph Jones. Still going strong, it looks far different from the pub shown in the old photograph that was taken before the 1939 rebuild when it gained its black and white mock-Tudor front elevation. I have to say that having seen photos of the old pub it looks far better now. This is recorded on the front, showing on one side the date of the original building which was 1506, although this could be 1508 as there is a strange squiggle on the letter 6. Then on the other side the date of rebuilding: 1939. A pub that has been tastefully renovated leaving much in the way of ancient dark wood, plenty of room in this large old city centre pub.

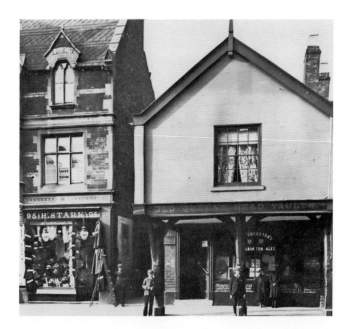

Ye Olde Queen's Head,
early 1900s.

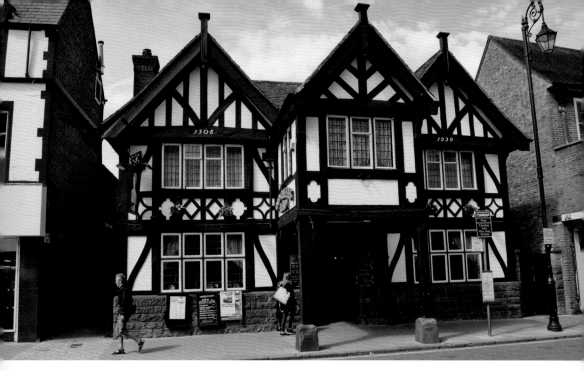

Ye Old Queen's Head, 2015.

The Union Vaults

This is a good old-fashioned boozer of the kind once seen on every street corner. Situated on the corner of Egerton Street, this is a really nice friendly pub with a loyal clientele. I took a photograph inside and had a bit of friendly banter with the customers. Well, I think it was banter unless they really did want paying hundreds of pounds for the photo! The customers included off-duty postmen who had been up since 4 a.m. and were having a quickie on the way home. It is such a pity that there are so few of these old Victorian pubs left as they were once a happy part of the community. Well at least the Union Vaults is still there and with the support it seems to have I have no doubt that it will continue well into the future.

The Compass

This City Road pub (overleaf) can be found at the end of the underpass from Northgate Street in an area that has seen much change during which it managed to avoid demolition. A beautiful large mock-Tudor pub filled with the ambience of old wood, bare brick and wood floors with ample cosy areas to sit. Built originally as part of a terrace of four shops and designed by the noted architect T. M. Lockwood. Downstairs is a traditional town centre pub and in winter there is an open fire. Upstairs there is a popular music venue and there is a pleasant outside area at the front from which to enjoy a drink and watch the world go by. It was previously known as Jones's Wine Bar and before that, Last Orders and The Chester Hangman. Just outside the city centre on the road to the railway station it has a lot of passing trade. It is on two floors and was built in 1908, having been commissioned by The Duke of Westminster.

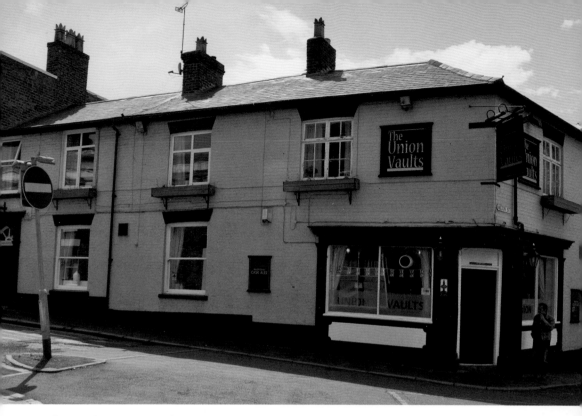

Above: The Union Vaults.

Below: The interior of The Union Vaults.

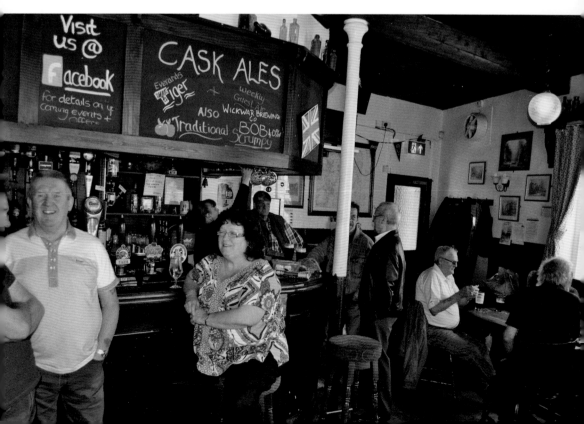

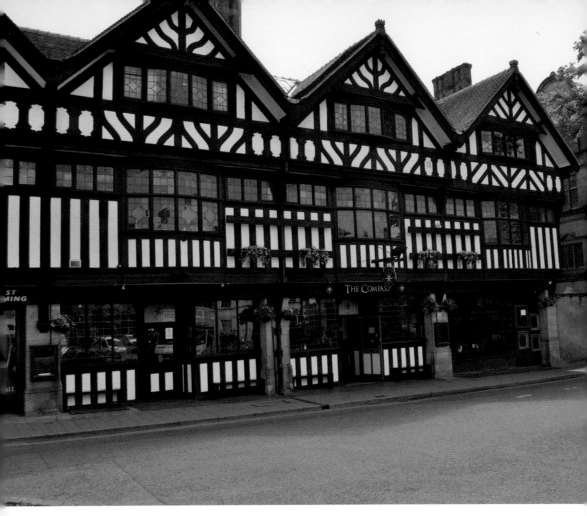

The Compass.

The Bridgewater Arms

The Bridgewater Arms is situated at No. 16 Crewe Street just a few minutes' walk from the railway station and as such was in a position to cater for the people working at the new Chester general station when it was built in 1848. It soon became a popular pub for the railway workers working on the Chester Railway. In 1873 it is believed to have been called The Napier. For a while the pub also served as hotel to the station and was listed in *Slater's Directory* of 1880 when the landlady was Mary Campbell. In 1910 it was listed in *Kelly's Directory* as 'The Bridgewater Hotel, Landlady Mrs M. A. Bass', who was still there in 1914. In 1934–35 the landlord was Edward Hargrove. The Bridgewater Arms is a pub that dates from the early 1800s. This welcoming old pub has now been modernised inside and boasts the cheapest beer in Chester. A typical corner pub with a faithful clientele, how nice to see that all of the old pubs in Chester have not been swept aside in the interest of road building and modernisation and, it has to be said, lack of sufficient custom to satisfy the owners.

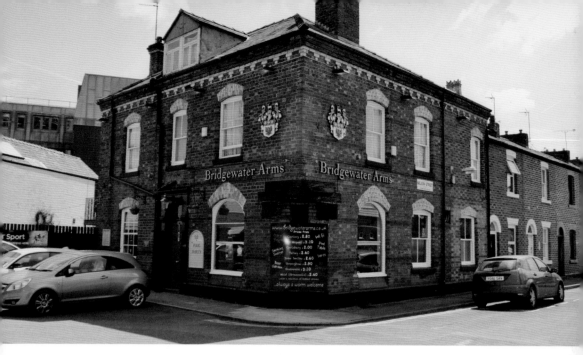

Bridgewater Arms.

The Old Harkers Arms

Situated on the ground floor of an old canal warehouse that has now been transformed above into a Thai restaurant, we find a truly great pub. I'm sure the owners won't mind me telling you how this great pub came about. The owners, having spent time down south watching prices going up and up, decided, in 1985, to look to the North for more affordable buildings. They soon found the ground floor of a canal warehouse that had been used by a Mr Harker to run his canal-boat chandlery business. Well, this rough neglected basement did lead out onto the tow path of the Shropshire Union canal.

What confronted them was a ghastly dripping-wet cellar with bricked-up windows and a garage at one end, pierced by the bulk of a lift shaft which serviced the floors above. To make it usable they would have to tank the whole area and terminate the lift shaft at the floor above, which would mean heavily reinforcing the ceiling so there would be no danger of the lift crashing through if its cables broke.

Because the site was in a rundown part of town, and the site itself needed more than a lick of paint, none of the local banks believed it would work and declined to finance it, which is where it all got a bit iffy. In the end they managed to persuade a large venture capitalist to lend them the money that was needed. The deal was done and the work started to turn this mess into a bar to be proud of and they certainly succeeded. The food and the selection of drinks are first class with ten cask ales. The ambience is appealing and the pub was named as Town Pub of the Year 2015 in *The Good Pub Guide*. Some have compared it to a very successful London pub and I couldn't really disagree with that. Brunning & Price, with Old Harkers and also The Architect in their stable, are certainly doing something right in Chester.

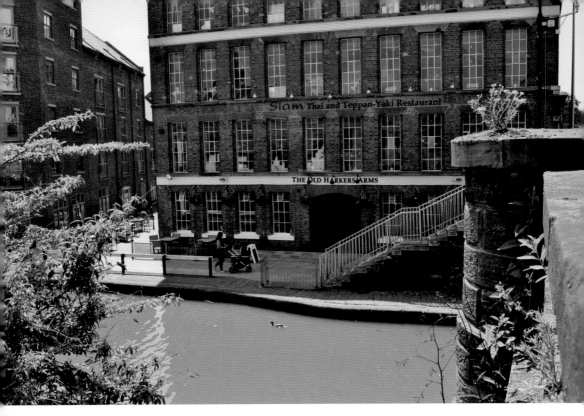

Above: Old Harkers.

Below: The interior of Old Harkers.

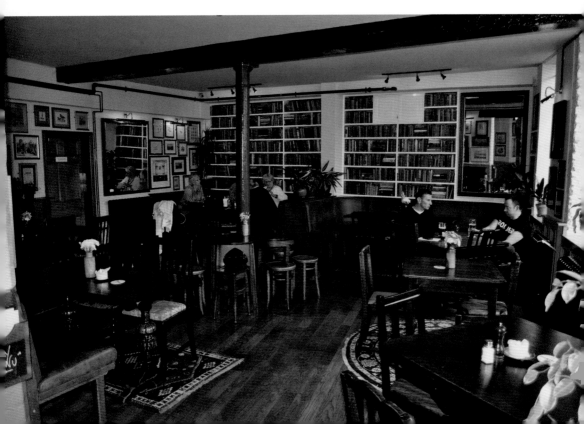

Egerton Arms

Now in Brook Street, an area that once had many pubs to choose from, now just has a few left and one of these is the Egerton Arms, a traditional boozer that has stayed the course and continues to attract custom from the area. Brook Street is in the Chester suburb of Newtown, an area that has suffered redevelopment and road building. At one time it was the powerhouse of Chester with the adjoining areas of Boughton and Hoole; most of the workers in Cheshire during the Industrial Revolution came from the area. Chester's economy was driven from the 1790s by its close proximity to the canal network and later from the 1840s by the location of the railway networks, Chester General and Chester Northgate being in the area. There were many working class families in Newtown and tradesmen with businesses in the area. The last canal-side flour mill only closed in the 1950s. It was this activity that Brook Street was in the centre of and this is the reason for the number of pubs there at one time. Now one of those left is The Egerton Arms. In my directory for 1828 the only Egerton Arms was in Northgate Street; by 1860 the only Egerton Arms was in Egerton Street but by 1896 the landlord of the Egerton Arms in Brook Street was William Billington so that tends to date the opening of the pub to roughly the period between 1860 and 1896. By 1914 John E. Jones was the landlord.

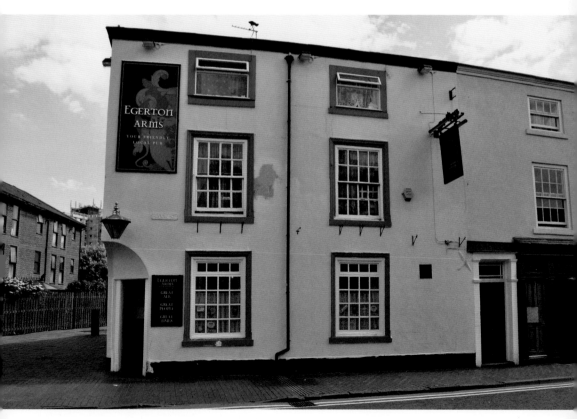

Egerton Arms, Brook Street.

Stanley Arms

Still in Brook Street we come to the end where it meets the Inner Ring Road and we find an exceedingly attractive pub. Fresh from a total refurbishment by the new owners who took over last year means that it is as attractive inside as it is outside. Built during the reign of Queen Victoria, in 1828 there was no Stanley Arms listed but by 1860 John Carter was the landlord. By 1880 it was John Lewis and by 1902 Peter Hughes was in the chair.

The Stanley family were landed gentry from Chester and one of the most prominent aristocratic families in Britain. John Thomas Stanley was the 1st Baron Stanley of Alderley who lived from 1766 to 1850. He was succeeded by Edward John Stanley 2nd Baron Stanley of Alderley who lived from 1802 to 1869. He was also known as Lord Eddisbury. His successor was Henry Stanley who converted to Islam and became the first Muslim member of the House of Lords when he adopted the Muslim name Abdul Rahman and he was also a bigamist (or may be that was legal in his adopted religion). His sister Viscountess Amberley was the mother of philosopher Bertrand Russell.

But back to this book on pubs Henry Edward John Stanley, 3rd Baron Stanley of Alderley and 2nd Baron Eddisbury, alias Abdul Rahman ordered the pubs on his estate at Nether Alderley (then known as Chorley) near Macclesfield to be closed in accordance with Muslim teaching.

Another interesting snippet is that one of the most haunted buildings in the country is Stanley Palace in Watergate Street. This was built in 1591 for Sir Peter Warburton who died in 1621; his daughter inherited the house and she married Sir Thomas Stanley who gave the house its name. After the English Civil War, the 7th Earl James Stanley was held under arrest in the palace to await transport to Bolton for his execution.

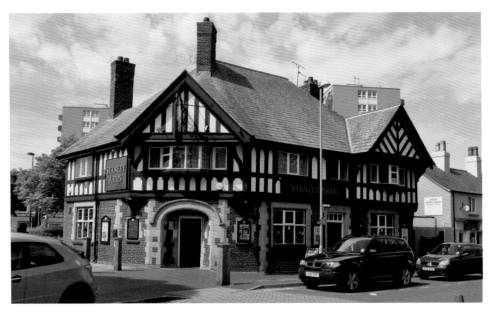

Stanley Arms, Brook Street.

The Olde Cottage

Still in Brook Street we look at a pub that CAMRA have officially named as the second best pub in Cheshire. This is according to the 2014–2015 Cheshire area Pub of the Year Awards. Another of Chester's attractive mock-Tudor black and white pubs, the Olde Cottage Inn is not shown in my 1828 *Pigot's Directory* but it is in the 1865 one when it was described as The Cottage Inn with Alfred Bloor as the landlord. Speaking to the present landlord, Trevor, he informed me that at one time the pub was split into two with a cheese shop next door; looking at the photograph, this would indicate that the information is correct. Also, an extra floor had at some time been added. Either way it is a very attractive building with a loyal and happy clientele.

The Cross Foxes

This attractive pub is in Boughton at the far end of Northgate Street which in days of old did continue further than it does now past The Barrs. This was a name given to the location of an outer defensive fortification for the city. Now it simply leads into Boughton and on the left can be found this mock-Tudor public house by the name of the Cross Foxes where in 1828 Elizabeth Dean was the landlady; there was also another pub called The Cross Foxes on Northgate itself where Miles Harrison was the landlord and by 1910 William J. Chester was in the chair.

But what a strange name and where did it come from? It could originate from Wrexham and from the Sir Henry Watkin Williams-Wynn who owned land extensively in North Wales and whose family crest shows two sets of foxes crossing each other. Williams-Wynn was elected MP for Denbighshire in 1841 and held the seat until

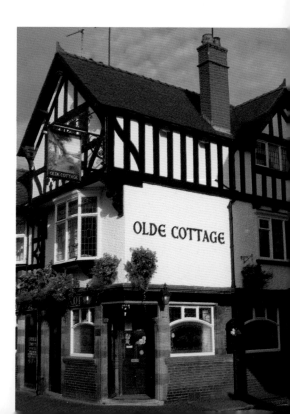

The Olde Cottage.

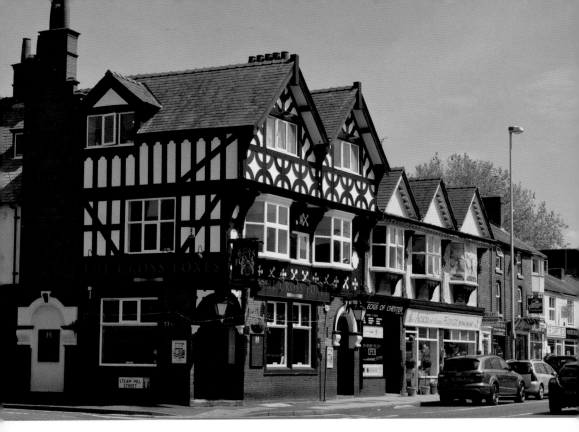

The Cross Foxes.

he died in 1885 aged sixty-four. Interestingly, the seat had been held before him by his father, grandfather and great-grandfather, all of whom had the name Watkin Williams-Wynn. Hence, there are quite a few pubs in North Wales with the name The Cross Foxes. That is the local meaning and almost certainly the reason for this pub name. Before we leave pubs outside the walls that are still trading, let's have a few without photographs.

The Boathouse on the Groves

The Groves comprises Chester's promenade although not at the seaside but on the river. It is an ancient area, taking the tourist or casual traveller from the famous Old Dee Bridge along the riverside and through to Boughton, stopping on the way, should you want to deviate slightly, to visit The Amphitheatre and Grosvenor Park. But also on the way you will pass firstly the Grosvenor Rowing club in its beautiful building with its viewing balcony, designed in 1877 by Thomas Lockwood, the designer of the attractive No. 1 Eastgate Street. As you pass this building there is a sharp left turn as you reach The Boathouse pub. Go left to carry on along the Groves, right to cross the footbridge or straight on to the Boathouse pub. The pub's address is No. 21 The Groves, a pub that sits on the river bank and has outside seating with a perfect view of the river and all of the many activities on it. Building work is ongoing to enable the pub to provide accommodation from September 2015.

They have now moored a 19-ton flat-top barge at the side of the pub on the river and seats have been placed on top of it. This gives the already large pub an excellent vantage point to watch the world go by and enjoy the sun. The view is also of the famous Queen's Park suspension bridge that is a footbridge from The Groves to Queen's Park across the river.

The Cellar

Well, we have now found the CAMRA bar of the year, for 2014 anyway and it is situated at Nos 19–21 City Road where they boast the widest selection of beers in Cheshire. Below, the pub is situated in a nondescript building which belies the interior that is filled with pleasant decorations and ambiance. Also below the building is Brown's Crypt that is reputed to be an undercroft once situated under a wealthy merchant's townhouse. There is a bare brick bar at street level and every weekend they have live bands playing from 10 p.m. and the cellar bar is available for hire.

Artichoke

There is certainly no shortage of good bars and pubs in Chester and the Artichoke at the Grade II-listed Steam Mill in Steam Mill Street down by the canal is certainly one of those attractive watering holes. A few hundred yards from another excellent pub, Old Harkers, it is in what is called the canal corridor which follows the route of the Shropshire Union Canal eastwards from the City Centre for a mile between Brook Street and Tarvin Road. This attractive bar can be found in the old Steam Mill building in the road of that name. Time for a bit more history. The steam mill was built for corn and flour merchants on a site that was formally fields and the purpose-built mill was built on the bank of the newly opened Chester to Nantwich canal. The mill is first recorded on an engraving in 1789 but in 1785 it was fitted with a Bolton & Watt engine that had only just been invented. Over the years the premises were enlarged until now, when it houses business premises, offices and of course the Artichoke Café Bar and Bistro.

Bar 69

Can be found at No. 1 Boughton and is Chester's second gay and lesbian venue. An eclectic choice of music is played by resident DJs.

Number Fifteen/Fifteens at Chester

Number Fifteen, a popular bar at No. 98 Foregate Street, is always a favourite with race-goers, tourists and locals alike. There is no shortage of atmosphere in this city centre bar. During the day there is homemade food on offer, all provided by a friendly staff. By night DJs take over with occasionally live music as the partygoers arrive for a night of music and fun.

The Square Bottle

Another highly popular, large modern bar at Nos 78–92 Foregate Street and the second Wetherspoons pub in the city. But what of the building that houses it? The address

Nos 78–92 Foregate Street was once Nos 78–94 and is a Grade II-listed building. In 1904 to 1905 it was built for the Chester Co-operative Society as a department store, the designers being Douglas & Minshull. In 1914 it was extended and originally opened up into Foregate Street and Love Street. When built the City Council were not happy that the building was not built in John Douglas's normal Vernacular Revival style, so the builders agreed to fit partial leaded glazing in order to gain the Improvement Committee's approval. Then in 1980 it was converted into a row of shops and later transformed by Wetherspoons into a large city centre bar.

The Town Crier

A very impressive pub that was built in 1865 as a hotel to cater for the passengers alighting from the train across the road at Chester General Station. On the other side of City Road was the Queen Hotel that was specifically built for first-class passengers from the trains. The original name of the Town Crier was The Albion Family and Commercial Hotel although for a very short time it may have been the Queen Commercial Hotel but by 1880 it was The Albion. It was built as a companion to The Queen over the road and it was to welcome those from the trains who were not first-class passengers. By then, City Road had come into being to cater for the new station which was originally in Hoole and had been moved to its present location and City Road built to accommodate it. The two hotels were linked by an underground passage but apart from a few feet at one end, it has been bricked up. A very nice pub that now welcomes all, and not just the passengers from whatever class alighting at the station.

Telford's Warehouse

Located alongside the Shropshire Union Canal, we find a large Grade II-listed building in the form of an old canal warehouse. It was constructed in about 1790 having been designed by the famous canal builder Thomas Telford. Part of the building overhangs the canal to aid loading into it from canal boats in a dry environment. It is one of the more interesting features in this interesting city of Chester. It was in the 1980s that the warehouse was converted into a pub. Unfortunately there was a fire in 2000 that caused a lot of damage and it took a year to transform the pub back to its former glory. Telford's Warehouse has had a complete change of use from servicing the horse-drawn canal boats on the canal to servicing a wide spectrum of customers, some of who come for the excellent bar with its cask ales, European beers and extensive wine list. Its upstairs restaurant and gallery with its relaxed service has excellent menus. Then there are the well-known music nights where known and respected artists perform in surroundings most suited to this form of entertainment.

Commonhall Street Social

A final dip into these bars that are still trading and performing a service for the people of Chester. Here we have a bar, restaurant and pub that was once called the Weighing Room but has now evolved as the Commonhall Street Social which needless to say can be found in Commonhall Street. It is a very popular pub that is situated in an old mill and the interior has been tastefully converted in a rustic fashion with items from its

past life still on view. Time has quite tastefully been turned back here, tucked away as it is off Bridge Street the exposed bricks and beams are joined by retro board games and a good old-fashioned night or day out.

Watergate Inn

Crossing the Inner Ring Road and into lower Watergate Street we find an old pub situated just through the Watergate and close to the Chester racecourse on Watergate Square. Its old name of the Turf Tavern was probably more apt for a pub that is almost within the confines of the oldest racecourse in Britain. Accordingly it has, for around 200 years, served the punters at The Roodee. Before that and much earlier, this was in an area of sailors, sailing ships and all of the baggage that this occupation carried, especially in the days when Chester was a port when clay pipes would be smoked and ale supped by men with weather-beaten faces, men who had sailed the world in tea clippers and wooden-hulled warships. (That is if they were not quick enough to avoid the press gangs who would almost certainly have prowled this old port.) This whole area was built upon and the attractive Georgian houses that can still be seen in Lower Watergate Street once carried on through the Watergate but those have now been demolished to extend and alter the roads and provide car parks. In this area as late as 1860 could be seen trading Nathaniel Cox, proprietor of the Roodee Ship Yard in Paradise Row. Also William Parkes at Dee Bank shipyard in Crane Street. In 1828 when the pub was known as The Watergate Tavern, Robert Evans was the landlord. By 1914 it was Joseph H. Burrows who was landlord of the Watergate Inn.

Watergate Inn.

Chapter Four

Chester Pubs Outside the Walls That Have Now Gone or Left the Brewing Trade

A look now at a few of the more impressive pub buildings outside the Chester Walls. Firstly we pass under the Chester Clock in Eastgate Street into Foregate Street to find a few pubs that have now stopped trading. There are in this city centre road quite a few attractive Chester buildings, a lot that are listed: once busy pubs they have now been transformed into retail premises.

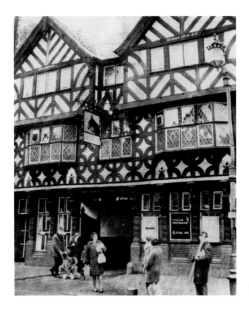

The Olde Nag's Head c. 1950s.

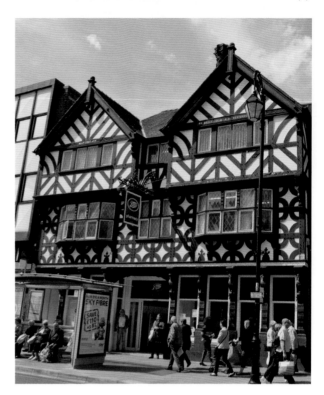

The Olde Nag's Head Hotel
(now Boots), 2015.

The Olde Nag's Head

Although the building no longer houses a pub it is still a beautiful black and white building that now houses a branch of Boots the Chemist. The floor of the old pub has been greatly increased to cover what was an abattoir in Queen Street at the rear. The entry to the rear of the building has also been incorporated into the new shop premises. The earlier Nag's Head was built in 1597 as is recorded on the front elevation but was completely rebuilt in 1914 and then restored again in 1980, which dates are also recorded on the front. In 1788 it was owned by Aaron Miller who went bankrupt and was sold in the same year and appears to have been purchased by a Mr J. Whalley and by 1828 Mr George William Walker was the landlord. It closed in 1970 and is now retail premises.

The Brewer's Arms

A few doors away from the Olde Nag's Head was a pub that really needed demolishing due to the state of it as can be seen in the old photo overleaf. It was at that time the Brewers Arms and in 1828 John Huxley was the tenant. The old Brewer's Arms was demolished, probably in the late 1800s and the Green Dragon that was originally in Eastgate Street was sold in 1893. The licence was transferred to the old Brewer's Arms site and the new building became The Green Dragon. This was in the style of extremely attractive mock Tudor that was becoming a common style in Chester and has made Chester such a beautiful city. The modern photograph overleaf shows it as it is now, a branch of the Abbey National Building Society.

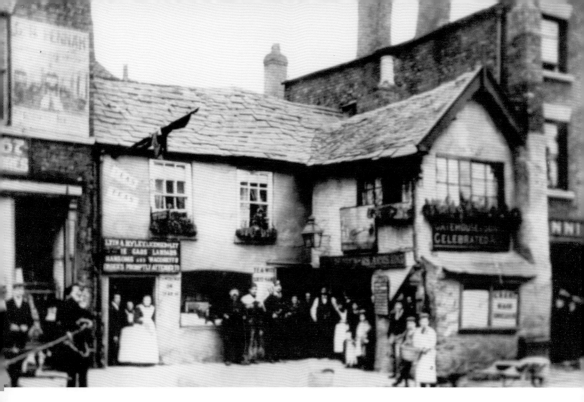

Above: The Brewer's Arms/Green Dragon.

Left: The Abbey National building.

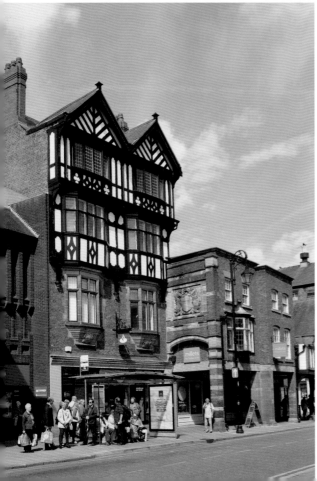

Ye Olde Royal Oak

Across the road from The Olde Nag's Head could be found another beautiful building in the form of Ye Olde Royal Oak. The first photograph is of the pub as it appeared in 1900 with its date of building as 1601. Then we see the rebuilt pub after 1920 when it was built in the beautiful mock-Tudor style. The original date of the rebuilt building can also be clearly seen on the front elevation, it was 1601. The date of rebuilding is also there, 1920. Also plainly seen is the name of the pub from this rebuild, Ye Olde Royal Oak Hotel with an oak tree carved on the front elevation. An even older pub by the name of The Crow was on the site in the 1500s. In 1789 the tenant was a Mrs Faulkener. During the 1980s the pub closed down and a further refurbishment took place turning it into a retail premises. It now houses a branch of Holland and Barrett.

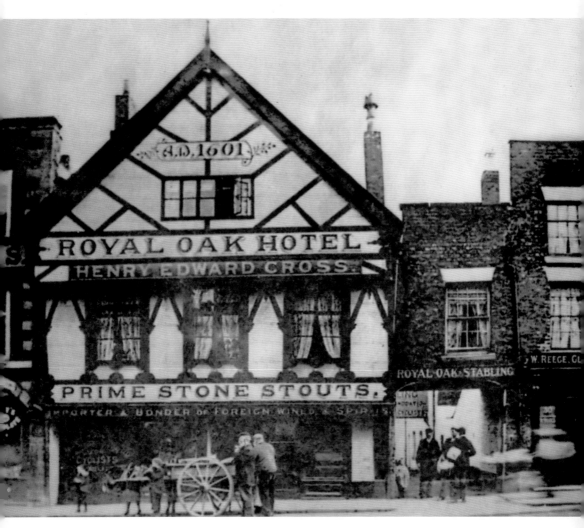

Ye Olde Royal Oak, 1900.

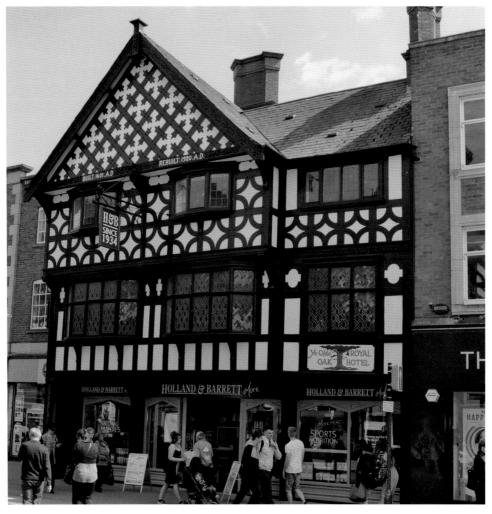

Ye Olde Royal Oak, 2015.

The White Lion

As we continue to the lower end of Foregate Street we reach what was once the old black and white pub called the White Lion. In 1829 John Wooliscroft was the tenant. Chester suffered very little in the Second World War as far as bombings were concerned, but the White Lion took a full hit by a stray bomb. The bomb struck the modern extension built in place of the black and white building that stood there before. As can be seen in the old photograph, the pub had two wings, one was traditional, the other was very box-like and rather unusual and both wings stretched over the footpath. It was this box-like wing that the Germans decided to bomb out of existence. The wing has now been rebuilt and the whole pub converted into a row of shops. Other than the rebuilding of the bombed wing and the change of use, little has altered in the old and new photograph.

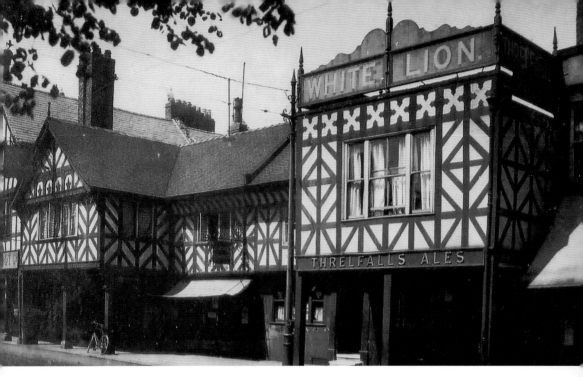

Above: The White Lion intact, *c.* 1920s.

Below: The White Lion, 2015.

The Bull & Stirrup.

The Bull & Stirrup

This large and impressive pub closed at the end of August 2014, but if rumours are correct it will be opening soon as a Wetherspoons hotel, situated at the end of Upper Northgate Street at No. 8, just outside the city walls and the North Gate. The pub once had behind it gorse stacks and its cattle market so was a handy place for the buyers and sellers to meet and the reason for its name. This impressive red-brick building dates from the early nineteenth century, and in 1828 had Thomas Higginson as the landlord. For a while in the appropriately named 'Naughty's' and perhaps a little earlier it had the dubious honour of being Chester's Strip Pub when regular strip shows were provided for discerning punters on the second floor.

The Swan Hotel

Now for a hotel that was not demolished to make way for the ring road but simply to redevelop the site. In the 1960s, The Swan Hotel at No. 60 Foregate Street was one of Chester's most prestigious and deserves a mention here. Records identify the hotel as being there in 1540 as the Swan Inn, it later devolved into the Swan Hotel and it was one of Chester's best known and most prestigious of hostelries. Three hundred years later it was said to have extensive gardens to the rear of the premises and included a fair number of cellars, tenements and shops. Prior to the dissolution of the monasteries it had come into the ownership of nearby St John's church. Then afterwards it was purchased from The Crown by a man from Northwich called John Deane who was born in Shurlach between Davenham and the Rudheath district of Northwich.

The Swan Hotel.

He rose to be the Rector of St Bartholomew's the Great in Smithfield, London and was eager to leave a lasting legacy for the children of Northwich. He was said to have established a grammar school for poor boys in Witton in 1557 'In the name of Jesus'. It was to be maintained as a charity that was given land in Chester for the purpose. In fact, he donated all of his property holdings in Chester to this end of which The Swan was one of his properties. Over the next few hundred years the trustees of the Witton Grammar school retained and leased the Hotel (the grammar school still exists as Sir John Deane's). The Swan Hotel continued to serve the people of Chester through the nineteenth and well into the twentieth century although the land was sold off. The Tatler cinema was built next door and both buildings sat side by side until 1972 when both were demolished to make way for a modern shop development.

The Angel Hotel

The Angel Hotel, was situated at No. 96 Brook Street, on the triangle of roads that made up Egerton Street and Francis Street. Five pubs once faced each other at this junction – the Angel Hotel, the Glynne Arms, the George Hotel, the Railway and the Egerton Arms. Of these five only two buildings still exist: the Railway and the Egerton Arms. The Railway Inn is now an undertakers and the Egerton Arms is still a thriving pub. The site of the Angel Hotel is now occupied by the Chester Lodge Residential Home.

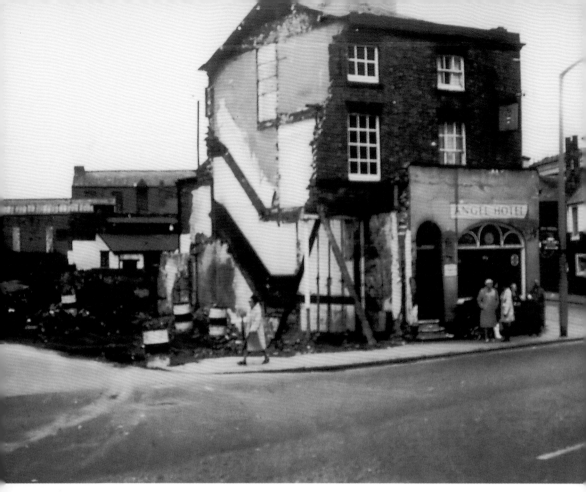

The Angel Hotel.

Ormonde Guest House, Brook Street

Still in Brooke Street at No. 126 we find another attractive black and white building that obviously used to be a hotel but is now a guest house. Its date of closing as a pub is not very clear but is believed to be the 1950s. The Marquise of Ormonde is an Irish hereditary title, and apart from a minor incursion into the Chester history books during the English Civil War when he sent Irish soldiers to fight for the king under General Byron there is not a lot more that I can tell you. He did write to the mayor of Chester asking him on behalf of the king to look after the Irish troops.

However, a horse called Ormonde was a favourite of the 1st Duke of Westminster. Ormonde lived from 1883 to 1904 and is reputed to be one of the greatest racehorses ever. He was a thoroughbred and won the Champion Stakes and the Hardwicke Stakes twice and was the unbeaten Triple Crown holder, at the time he was called 'The horse of the century'. Ormonde was trained at Kingsclear for the duke. After retiring he sired another racehorse called Orm who won the Eclipse Stakes twice.

As for the pub, it is not shown in the *White's Directory* for 1860 but by 1896 Thomas Bayley had taken over the reins, dating it between those times.

Ormonde Guest House, Brook Street.

The Parish Centre

As we reach the end of Brook Street opposite the Stanley Arms, we find the Parish Centre for St Werburgh's. Both buildings are like book ends at the end of Brooke Street before the Inner Ring Road chops of the end of old Brooke Street. I have listed it as a pub that no longer trades as such although this is not totally true as it does now contain a bar. I would class it as a stunningly beautiful double winged building with the door in the centre of the two wings. It closed as a pub in 1975 and since then has been St Werburgh's Catholic Parish Centre. The church itself is just five minutes away. The parish of St Werburgh dates from the 1799 but the new church was built in the 1870s in Grosvenor Park Road.

The Parish Centre building, or The Bowling Green building itself is very old and the bowling green at the back was one of the oldest in the country having been in use since the sixteenth century but was partly destroyed in 2001 when some of it joined the surrounding land to be sold for the development of retirement apartments. As is quite common with these developments, they resulted in complaints with regard to music they could hear from the social club! Just remind me what came first, an ancient entertainment building or new, old people's flats, difficult one that! The bowling green then became an overgrown decorative lawn but I think it has now been renewed as a bowling green and is in use as such. In 1828 Thomas Whittingham was the landlord and the original Bowling Green pub was demolished in 1911 and the wonderful building that we see there now was built to replace it.

The Old Bowling Green, Parish Centre, Brook Street.

The Ship Victory

Here we see a well-loved pub that closed in January 2014 when the last landlord retired. A group called The Friends of the Ship Victory was formed to try and keep it as a pub, it is however the property of Cheshire West and Chester Council and the appeal was to that body who refused the application! Their plan was to demolish the pub and turn the land into a bus station. The Ship Victory was once in the company of a string of pubs that faced Chester's Cattle Market, or Beast Market as it was also called, the market was on Gorse Stacks. The pubs were thriving when the market operated but one by one closed down as the market custom was lost. The Ship Victory continued to thrive with a loyal clientele being known as the little pub with the big heart and it is believed to be the only pub in Britain named in this way after Nelson's flagship, currently open to visitors in Portsmouth. It is not shown in *Pigot's Directory* for 1828 but we know that in 1889 the pub was extended into the building we see today. There are pubs called The Victory Inn and other derivatives of the name but none called The Ship Victory. In 1914 and into the war the landlord was John Thomas Cunnington.

Ship Victory, Gorse Stacks.

The Ring O'Bells

Now we come to what was the corner of City Road and Foregate Street, now part of the Inner Ring Road and roundabout. The photograph overleaf was taken in 1969 of the Ring O' Bells and Grosvenor Park Hotel and that was just before they were demolished. The Grosvenor Park Hotel was on the corner of Foregate Street and City Road and in 1871 went by the name of the Newpark Hotel. By 1896 it was the Grosvenor Park Hotel with the address City Road and with Mrs Hannah Billington in charge. The landlord from 1957 to 1963 was William Wikeley. An old Chester joke was 'What's the shortest distance between two pints?' The answer, of course, was 'From the Ring O' Bells to the Grosvenor Park Hotel!' The hotel was popularly known as Dick Scott's as its landlord during the years of the Second World War was E. J. H. Scott.

Next door, we would have found the Ring O' Bells which was situated at No. 145 Foregate Street. It appeared in *Cowdroy's Directory* in 1789 when the landlord was Simon Hawkins. In 1828 the landlord was Thomas Bithell and in 1896 John Walker. In common with numerous other Chester pubs, the original building had been demolished during the nineteenth century and replaced with a more attractive mock Tudor façade. There was actually a third pub on this row that also went to allow the Inner Ring Road to pass through. That was called the Queen's Head hotel and this was on the corner of City Road and Seller Street where in 1896 Thomas Ball was the landlord. Together with the abovementioned Grosvenor Park Hotel and the Ring O' Bells, it was demolished to make way for the Inner Ring Road. The site is now occupied by the Grosvenor Court offices and the City Road roundabout.

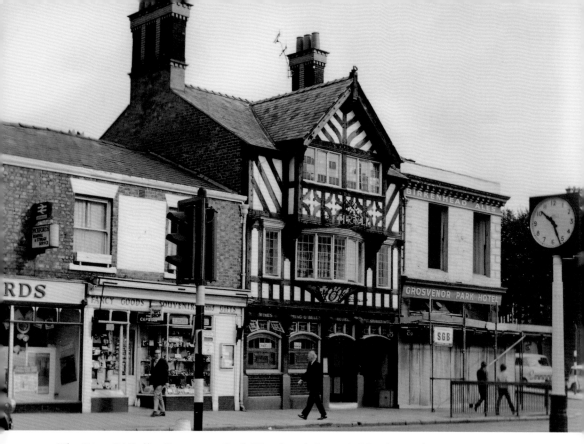

The Ring O' Bells, Grosvenor Park Hotel and Queen's Head Hotel.

Chapter Five

Hotels Still Trading with Bars Open to the Public

The New Blossoms Hotel

Let us now have a look at some of the hotels in the city that are not really classed as pubs although they do have bars and are open to the public, starting with The Blossoms Hotel. This large hotel, now called The New Blossoms Hotel by its owners Macdonald Hotels, is the oldest hotel in Chester having been first opened in the year 1650 and its period charm blends comfortably with its modern facilities. The hotel straddles St John Street and Foregate Street with the main entrance it St John Street. In 1895 it was rebuilt in the red brick style that can be seen today. Before this it was on Foregate Street on the site of what was the Westminster Bank building, now the Lush shop in Foregate Street. In its early existence The Blossoms was an important hotel together with its close neighbour The Golden Talbot. Both were – at the time – centres of the social and political life of Chester. The Talbot later went on to be The Grosvenor and we will look at that next. In those days the inns and hotels did more than just house tourists and travellers. They were places for selling everything from horses to buildings. Local craft workers would have premises and outbuildings in their yards for the manufacture of assorted items. All in all hotels were very important buildings in the city and the Blossoms was the oldest of them.

The Chester Grosvenor Hotel

Around the corner from The Blossoms and in Eastgate Street beside the gate we find Chester's most important and prestigious hotel, now known as the Chester Grosvenor. The name Grosvenor is attached to many things in Chester from shopping centres, roads, parks, museums, one of the most famous bridges in the world and this fine five star hotel. Grosvenor is the Duke of Westminster's family name and much of Chester's architecture dates from the Victorian era, many of the buildings being modelled on the

Jacobean half-timbered style, so beloved of the famous and excellent architect John Douglas who himself originates from Sandiway in mid-Cheshire. Mr Douglas was employed by the Duke of Westminster as his principal architect and in this capacity he remodelled Chester and its many decrepit buildings. He had a trademark of twisted chimney stacks, many of which can be seen on his buildings.

Douglas designed, among other buildings, the other Grosvenor Hotel on the duke's land at Aldford. Some of the more pedantic commentators describe the demolition of ancient buildings in Chester as vandalism and John Douglas a party to it. But to look at it a different way, those buildings were in the main so run down as to actually need re-building and progress is progress. By the mid-1800s traffic had increased from the days of a few coaches and horse-drawn traffic and the replacements in red brick and mock Tudor that Douglas designed were an excellent replacement. A replacement that has Chester listed as one of the most beautiful cities in Britain. If anyone doubts this, just look at the beautiful black and white building opposite The Cross in the city centre and then check out the photograph of what was there before. OK, this was designed by Henry Francis Lockwood, a man influenced by Douglas but it is an excellent comparison.

Over the road from the Grosvenor Hotel is St Werburgh Street leading to the cathedral. This street was once half the width that it was until it was widened and the east side redeveloped by The Corporation with the backing of the Duke of Westminster and the designs of architect John Douglas. Douglas wanted to build it in another of his favourites, red brick, but the Duke intervened and ordered him to build it in his trademark black and white mock Tudor which naturally John complied with. A plaque was erected here in 1923 in appreciation of the work done by John Douglas and it can be seen there today.

But we digress, back to the Grosvenor. It was built between 1863 and 1866 and is owned by the Duke of Westminster. Before the present building was constructed the site was occupied first by the pub The Golden Talbot and later by The Royal Hotel. The Golden Talbot was recorded as being 'ancient' in its 1751 mention in one of the local weekly newspapers and had been in operation during the reign of Elizabeth I. In 1784, the pub was demolished to make way for The Royal Hotel, built by the politician and landowner John Crewe and it became the headquarters of the Independent Party, who were the party opposed to the Grosvenor family, later to become the Dukes of Westminster. In 1815 it was purchased by Robert Grosvenor who was at that time Earl Grosvenor and who later became the 1st Marquis of Westminster. It was then renamed the Grosvenor Hotel, and it became the city's 'premier place to stay'. While it was in possession of the 1st Marquis' son, Richard Grosvenor, 2nd Marquis of Westminster in 1863, this building was demolished and the building now present on the site, again originally called the Grosvenor Hotel, was built.

It was designed by Thomas Mainwaring Penson and was Penson's last major work. It was completed after his death by his son's firm R. K. Penson & Ritchie. The hotel passed into the estate of the Duke of Westminster when Richard's son Hugh Grosvenor was made 1st Duke of Westminster in 1874. The Chester Grosvenor is the only five-star hotel in Chester and was as popular in the 1950s as it is today.

Lloyds of Chester Hotel

Once called The Liver Hotel in Brook Street, the old ugly duckling of a local pub, after a spell closed and abandoned has become a swan in the form of a boutique hotel called the Lloyds of Chester Hotel. Situated near the main Chester station in Brook Street, the Lloyds of Chester and the Liver before it are well placed to take advantage of tourists and travellers to Chester by train.

Westminster Hotel

At the bottom of City Road, No. 63 and near the railway station you will find the Westminster Hotel, named after the Duke of Westminster. Like the Queen Hotel coming up next, it is a Best Western hotel that caters for tourists to the city who also have arrived by train.

Queen Hotel

Another large and prestigious hotel is situated opposite Chester General Station. In fact, it is the largest hotel in Chester and was designed by the architect T. M. Penson and built in 1860; the original plan for the hotel was that it would cater for the first-class passengers alighting from the trains over the road at the station. The people not fortunate enough to travel first class could use the down-market Albion Hotel that later became The Town Crier on the opposite corner. The two hotels originally came under the same ownership and there was an underground passageway between the two that passed under the roadway. In 1861 when just one year old the Queen Hotel was damaged by fire and was rebuilt the following year by Penson and Cornelius Sherlock using the original plans but without the high roof and viewing platforms. Later in the hotel's life an additional porch was added on the City Road side. In 2003 the hotel underwent a multi-million pound refurbishment, restoring this excellent four-star hotel to its former glory. Throughout its history, many distinguished guests have enjoyed the hotel's facilities including Charles Dickens, Lily Langtry and Cecil Rhodes.

The Mill Hotel

The building in which this city hotel is housed was converted from the original Griffiths Corn mill. The ancient Griffiths Mill near Sellar Street, stood empty for many years until it was redeveloped, firstly as a furniture store called Chester Chair, and more recently as The Mill Hotel. The hotel comprises a total of 129 ensuite bedrooms, a conference room as well as a hairdressing salon. There are five dining options available: the Canaletto restaurant, the Flambé Steak Brasserie, the Peppermill Trattoria, the Deli Bar and the unique Cruiser restaurant. On Monday evenings there is a jazz band in the public bar, whilst Friday and Saturday are 'Wine, Dine and Dance' evenings. Guests may also participate in the Cruiser restaurant's fun casino.

The Abode Hotel

And as a final offering of Chester's hotels I give you The Abode. This is situated on what was the site of the ugly old police headquarters and when they transferred it to a

far more suitable site in Winsford, The Abode, complete with Chester Council offices moved in. They built what I think is quite an attractive building in its place, although I know Len disputes this, classing it as a carbuncle, but we can't agree on everything. Although the bar is open to the public it is not, like this final list of hotels, actually a pub so you will have to look elsewhere for a photograph. The hotel is four star and quite prestigious overlooking the Roodee with panoramic views from the top floors.

I hope you have enjoyed perusing this book as we have enjoyed compiling it. It is not a fully comprehensive list, especially of the hotels so we apologise in advance if some city centre watering holes have been missed. The pub trade is in flux at the moment and I hope that the number of pubs that are closing around the country each week will slow down. Chester has an eclectic mix of places to enjoy a drink and I hope that we have covered them. From the modern gastro pubs to the cosy old corner street pubs that are still there to find if you look for them. Whatever your preference you will find it in Chester so enjoy the book and do go and sample the subject matter in the form of this city's offering of beautiful and historic public houses and bars.

Appendix

List of Chester City Pubs from 1900 to the Present Day

Albion Hotel, City Road General Railway Station (The Town Crier)
Albion Hotel and Brewery, Park Street
Alma Inn, No. 88 St Anne Street
Anchor, Watergate Street
Angel Hotel, No. 96 Brook Street
Architect, No. 54 Nicholas Street
Axe Tavern, No. 45 Watergate Street, (Now Bar Lounge)
Bars Hotel, No. 126 Foregate Street
Barley Mow, No. 32a Oulton Place
Bear & Billet, No. 94 Lower Bridge Street
Bears Paw Inn, No. 21 Foregate Street
Beehive Hotel, Hoole Road, Hoole.
Belgrave Vaults, No. 2 Cuppin Street & No. 16 Grosvenor Street
Bell Tavern, Watergate Street
Birmingham Arms, No. 15 Lower Bridge Street
Blue Bell, No. 55 Northgate Street
Boathouse, No. 21 The Groves
Boot Inn, Eastgate Street Row North
Bouverie Arms, No. 43 Garden Lane
Bowling Green, Nos 24 & 26 Brook Street
Brewers Arms, No. 61 Foregate Street
Brewery Tap, Nos 52–54 Lower Bridge Street
Bridgewater Hotel, Crewe Street
Britannia Inn, No. 11 Queen Street
Bull & Stirrup, No. 8 Upper Northgate Street (To be a Wetherspoon Hotel)
Bulls Head, No. 53a Northgate Street
Caernarvon Tavern, New Crane Street

Caernarvon Castle, No. 33 Watergate Street
Castle Inn, No. 42 Nicholas Street
Cestrian Inn, Nos 21 & 23 City Road
Chichester Arms, No. 44 Garden Lane
Coach & Horses Hotel, Northgate Street, (The Coachhouse)
City Arms, No. 32 Frodsham St (The Temple Bar)
Compass, 4–8 City Road
Commercial Inn, St Peter's Churchyard
Commonhall Street. Social No. 10 Commonhall Street
Cottage Inn, No. 32 Brook Street
Cross Foxes Inn, No. 25 Boughton
Cross Keys, No. 17 Northgate Street Row
Crown Vaults, No. 22 Lower Bridge Street
Crown Vaults, Sellar Street, Canalside
Crown & Anchor, No. 7 Princess Street
Crown & Glove Hotel, No. 118 Eastgate St Row
Custom House Tavern, No. 39 Watergate Street
Drovers Arms, Watergate Back Row
Druids Arms Sellar Street
Dublin Castle, No. 35 Upper Northgate Street
Dublin Packet, No. 21 Northgate Street
Duke Of York, No. 2 Frodsham Street
Durham Ox, No. 37 Tower Street
Egerton Arms, No. 94 Brook Street
Egerton Arms, No. 2 Egerton Street
Elephant & Castle, Northgate Street
Ermine Hotel, Flookersbrook
Exchange Vaults, No. 165 Foregate Street
Faulkner Arms, No. 40 Faulkner Street, Hoole
Feathers Inn, No. 33 Lower Bridge Street
Fiesta Havana, Nos 39–41 Watergate Street
Flint Boat House Inn, Crane Bank
The Forest House Lloyds No. 1 Love Street
Fox & Barrell, No. 18 Grosvenor Street
George lnn, No. 5 Black Diamond Street
George & Dragon, No. 21 Linenhall Street
Glynne Arms, No. 100 Brook Street
Golden Eagle, No. 22 Castle Street
Green Dragon Nos 59–61 Foregate Street
Golden Lion Hotel, No. 24 Foregate Street, (now Marks & Spencers)
Grosvenor Hotel, Eastgate Street
Grosvenor Tavern, Canalside
Grosvenor Arms, No. 132 Northgate Street
Grosvenor Park Hotel, Foregate Street
Grotto Hotel, No. 34 Bridge Street Row

Hop Pole Hotel, No. 13 Foregate Street
Horse & Jockey Inn, No. 33 Princess Street
Iron Bridge Inn, No. 41 Egerton Street
Kings Arms, No. 2 Union Street
Kings Arms, No. 40 Crane Street
Kings Arms Kitchen, Eastgate Street
Kings Head, Grosvenor Street
Lamb Inn, Lower Bridge Street
Linenhall Tavern, Linenhall Street
Liver Hotel, 110 Brook Street, (Lloyds of Chester)
Liverpool Arms, Watertower Street
London Bridge Hotel, Bridge St Row & No. 47 Bridge St
Lock Keeper, Canal Side
Lord Raglan, No. 26 Frodsham Street
Manchester Arms, No. 4 Princess Street
Mariners Arms, No. 21 New Crane Street
Market Tavern, No. 7 George Street
Marlbororough Arms, St John Street
Masonic Arms, No. 28 Northgate Street
New Inn, No. 28 Walter Street
Newgate Inn, No. 1 Newgate Street
Newgate Tavern, St John Street
Northgate Arms, No. 3 Victoria Road
Northgate Tavern, No. 77 Northgate Street
Number Fifteen/Fifteens, No. 98 Foregate Street
Oddfellows Arms, No. 4 Frodsham Street
Old Cross Keys, Lower Bridge Street
Old Kings Head, Nos 44 & 46 Lower Bridge Street
Old Nags Head Inn, Nos 47 & 49 Foregate Street
Old Pointer Dog, Watergate Street
Old Queens Head, No. 97 Foregate Street
Old Vaults, No. 30 Bridge Street
Ormonde Arms, No. 126 Brook Street
Painters Arms, No. 1 St Martins-in-the-Fields
Peacock Inn, No. 135 Francis Street
Pied Bull Inn, No. 49 Northgate Street
Plumbers Arms, No. 21 Newgate Street
Plumbers Arms, No. 39 Queen Street
Prince Alfred Inn, Egerton Street
Queens Arms, Nos 21 & 23 Brook Street
Queens Head Hotel, No. 135 Foregate Street & Seller Street
Railway Inn, No. 91 Brook Street
Raven Inn, No. 3 Frodsham Street
Red Bull Inn, Pitt Street
Red Lion Inn, No. 51 Frodsham Street

Red Lion Hotel, No. 7 Lower Bridge Street
Red Lion Inn, No. 51 Northgate Street
Ring O'Bells, No. 145 Foregate Street
Robin Hood, No. 14 Castle Street
Royal George, No. 35 George Street
Royal Oak, No. 16 Faulkner Street
Royal Oak Inn, No. 34 Foregate Street
Royal Standard, Castle Street
Saddle Inn, No. 29 Grosvenor Street
Shakespeare Inn, No. 92 Foregate Street
Shepherds Arms, No. 87 George Street
Ship Inn, No. 52 Crane Street
Ship Victory, No. 51 George Street
Shropshire Arms Hotel, No. 37 Northgate Street
Sportsman's Arms, No. 4 Linenhall Street
Square Bottle, Nos 78–92 Foregate Street
Stag Inn, No. 74 Northgate Street
Stanley Arms, No. 35 Brook Street
Star Inn, No. 32 Cuppin Street
Sun Tavern, Watergate Street
Sun Vaults, No. 9 Northgate Street
Swan Hotel, No. 52 Foregate Street
Talbot Hotel, No. 1 Newgate Street
Talbot Inn, Walter Street
Telfords Warehouse, Canal Basin, Tower Wharf
Three Tuns, No. 7 Frodsham Street
Town Hall Vaults, 1 & 3 Princess Street
Uncle Tom's Cabin/Leeswood Arms, Watergate Street
Union, No. 28 Foregate Street
Union Vaults, No. 44 Egerton Street
The Vaults, The Eastgate
The Vaults, No. 16 Watergate Street
The Vaults, Lower Bridge Street
Victoria Hotel, No. 2 Watergate Row
Watergates, Nos 11–13 Watergate St
Watergate Inn, No. 3 Watergate Square
Waterloo Inn, No. 67 Boughton
Wheat Sheaf Tavern, Watergate St
White Bear, No. 14 Lower Bridge Street
White Lion, No. 79 Foregate Street
Woolpack Inn, Northgate Row
Yacht Inn, No. 51 Watergate Street
Ye Olde Cottage Inn, Nos 34–36 Brook Street
Ye Olde Deva Hotel, No. 10 Watergate St, (now Amber Lounge)
Ye Olde Edgar, Nos 86 and 88 Lower Bridge Street